IMAGES
of America

WEST LONG BRANCH
REVISITED

IMAGES
of America

WEST LONG BRANCH
REVISITED

Helen-Chantal Pike

ARCADIA
PUBLISHING

Published by Arcadia Publishing
Charleston SC, Chicago IL, Portsmouth NH, San Francisco CA

Printed in the United States of America

Library of Congress Catalog Card Number: 2006935068

For all general information contact Arcadia Publishing at:
Telephone 843-853-2070
Fax 843-853-0044
E-mail sales@arcadiapublishing.com
For customer service and orders:
Toll-Free 1-888-313-2665

Visit us on the Internet at www.arcadiapublishing.com

Dedicated to the memory of my father, Dr. Robert E. Pike, whose hours spent teaching day, night, and summer foreign language courses at Monmouth College resulted in a palatial playhouse for his daughter

CONTENTS

ACKNOWLEDGMENTS

This volume of history made it across the finish line thanks to the energy and enthusiasm of fellow writer and graphics designer Maraliese Goosman-Beveridge, who graciously gave up cherished time at the historic Takanassee Beach Club in Elberon to make this book a reality. Many thanks, Maraliese.

The Highland Manor and early Monmouth College photographs in this volume were shot by the late Daniel Dorn Sr. and are but a glimpse of the extensive Dorn's Classic Images, the archive maintained by his daughter, Kathy Dorn Severini. Special thanks go to her husband, George Severini, for pinch-hitting.

Thank you to the director of the West Long Branch Public Library David Lisa, Pat Delahanty, Lynn Richards Steneck, Keith Christopher, Tracy Ilvento, and Peter Lucia.

For their patience and forbearance in waiting 10 years for this second volume to be published, thank you to Nancy Spear Rossbach, Lois Pollak Broder, Ruth and John DeBruin, Mary Iamello Sacco, Margery Carroll, Kathy Showler Elfner, Peggy McCall Wazley, Mimi Kates Lourenso, and all the Highland Manor alumnae.

A special thanks to Kevin Clark of the Design Consultancy, New York, for telling me about the nursery tiles in the Stanford White house and to Tony Senecal, Mar-A-Lago historian.

To Charles H. Maps Jr., whom I honored in my first volume, *West Long Branch*, I wish you could be here today to see how all the photographs we found together finally told the rest of the story of your home town.

And to Quentin Keith, may you rest in peace at last.

INTRODUCTION

In 1908, the village of West Long Branch asserted its municipal independence with a break from the more agriculturally dominant Eatontown Township, as it increasingly drew its cultural identity and cache from the famous Atlantic Ocean resort of Long Branch. By that first decade of the 20th century, the colonial coach stop had established a distinct town-and-country personality.

The community leaders were well-to-do farmers living along Monmouth Road, that all-important transportation thoroughfare connecting the Manasquan River in the southern half of Monmouth County to the South Shrewsbury River in the north, where New York City steamboats docked. Carriage makers and related artisans, plus members of the professional class such as lawyers, doctors, and architects, also populated the borough's village center, where Monmouth Road and Cedar and Locust Avenues intersected. Meanwhile the working class, an immigrant population that was largely Italian, had established itself mostly in Kensington Park, located at the borough's tightly drawn eastern border with uptown Long Branch. From the dawn of the Gilded Age in the 1890s, "the Branch" was a cosmopolitan destination that attracted those who loved the high life, including U.S. presidents, railroad tycoons, entrepreneurs, and well-known entertainers.

In fact, it was that proximity to New Jersey's second-oldest seashore resort and the largest in the county that drew not only the theater and publishing crowds but also those involved in New York's thriving retail industry. Everyone of note wanted large, airy country cottages near the sea, and they hired the leading society architects from New York and Philadelphia to give them estate homes that reflected their professional success and social standing. And so it was, until the stock market crash of 1929 changed a number of fortunes and the borough's history.

The country estate personality of West Long Branch remained until Eugene Lehman relocated his private all-girls academy from Tarrytown, New York, to two empty properties on Cedar Avenue. These included the handsome Stern residence and, across the street, the more opulent Parson palace, the only small-scale replica of Versailles in the United States. With Highland Manor's first graduation, West Long Branch began its historic makeover into a town-and-gown address, former gentleman's farms slowly giving way to the ever expanding campus of Monmouth University.

Within these pages you will be able to sojourn through history and glimpse the early-20th-century splendor of one of the jewel box communities on the Jersey Shore.

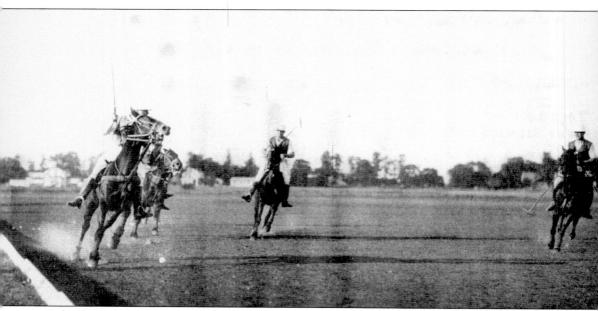

Polo, the sport of kings, came to West Long Branch as it did elsewhere around Monmouth and Ocean Counties. This rare image of polo players at the Norwood Country Club may have been taken from Locust Avenue.

One

THE NORWOOD COUNTRY CLUB AND COMMUNITY

As the 19th century flowed into the 20th, interest in invigorating leisure pursuits picked up, especially among the well-to-do and particularly with games of skill and strategy. The three leading sports that involved hand-eye coordination with a ball were polo, tennis, and golf. With plenty of open fields just beyond the borders of crowded Long Branch, the farming village of West Long Branch proved to be an ideal location for those seeking a genuine country experience while remaining in contact with the sophisticated entertainment and dining fare offered by a nationally recognized Atlantic coast resort. In 1902, the Hollywood Golf Club, then located in Long Branch, changed its rental arrangement and location by leasing three large adjoining tracts of flat open farmland that fronted on Locust Avenue in the borough. In all, the land amounted to 160 acres. The club initially had built a polo field and an 18-hole, 5,400-yard course. The assistant golf professional was John Showler; his wife, Mary Gibbons Showler, worked in the club office. In 1919, the clubhouse was constructed for $325,000, complete with a ballroom, space to sleep 20 guests, a kitchen, and men's and ladies' locker rooms. A second golf course was later added and said to have been the site of the second Metropolitan Open won by famed putter George Low of Baltusrol Golf and Country Club in Springfield. But after the 1912 season, the Hollywood membership decided to relocate again, this time to the country estate that financier George Young had built in Ocean Township for his wife, the opera singer Lillian Nordica. Initially incorporated on October 9, 1914, as the Norwood Golf Club, by December 2, 1926, the Locust Avenue property was known as the Norwood Country Club.

Polo Committee

MONROE EISNER, *Chairman*

NORMAN M. COHEN	HARRY MEYERS
MILTON ERLANGER	SIMON MILLER
N. J. STERN	HARRY F. SOMMER

Riding Committee

J. ERNEST STERN, *Chairman*

NELSON I. ASIEL	MRS. NORMAN S. GOETZ
MRS. A. LAMBERT CONE	CLARENCE A. WIMPFHEIMER

Caddy Committee

SIMON MILLER, *Chairman*

HERBERT C. KOTTEK DR. A. LAMBERT CONE

Golf Committee

J. HORACE BLOCK, *Chairman*

IRVING FEIST	HERBERT C. KOTTEK
MONROE F. HESS	LAWRENCE LEVY

ALFRED NATHAN, JR.

Women's Golf Committee

MRS. HERBERT C. KOTTEK, *Chairman*

MRS. LOUIS MANSBACH	MRS. RALPH B. AUSTRIAN
MRS. N. RANSOHOFF	MRS. S. ROSENBAUM

MRS. NORMAN S. GOLDBERGER

Garden Committee

MRS. NORMAN S. GOLDBERGER, *Chairman*

The search for local history often takes the form of scanning through honor rolls, fraternal yearbooks, and slim pamphlets published as membership books, complete with bylaws. This page from the 1930 membership book for the Norwood Country Club provides an opportunity to cross-reference family names with other ephemera to identify some of the area's country estates, owned by families from North Jersey and New York. These families include the Erlangers, Sterns, Cohens, Wimpfheimers, Feists, and Levys. It is quite possible that it was the members of the golf committee who hired A. W. Tillinghast, the patriarch of golf course design in the United States, to redo one of the two courses on the property. Annual membership was $5,000.

Perhaps the most publicly visible part of the club's pursuits was its polo games. Here is the scoreboard as seen on Locust Avenue near Franklin Parkway.

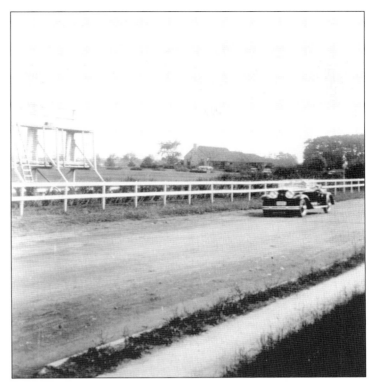

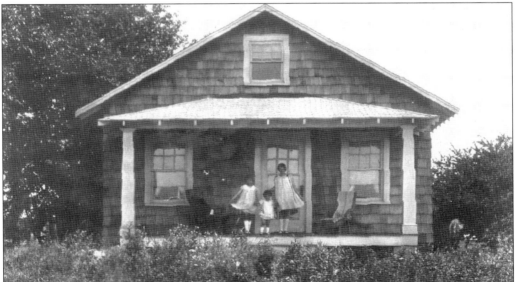

Visitors to the borough can gain a sense of how deep the club's property ran as they note the street signs for Golf Street off Broadway across from Kensington Park and Fairway off Wall Street just beyond Mount Carmel Cemetery. In this undated photograph, Harriet Covert DeCaro stands between her two older sisters, Loretta C. Conklin and Viola C. Rockhill, on their porch on the north side of Golf Street. Across the street is the eastern end of the golf course, where the ninth hole and a refreshment stand were located.

Belgian-born Joseph Damon, his wife, and his mother-in-law worked on the household staff of Louis B. Tim, a well-known Manhattan shirtmaker who owned a summerhouse in Long Branch (later to become the clubhouse for the Italian American Memorial Association). The three went into the restaurant business by operating what they called the Norwood Hunting Lodge. It opened in 1940 in the old clubhouse.

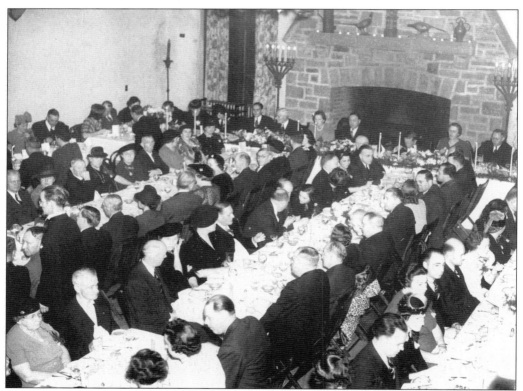

Here is a 1940 photograph showing a testimonial dinner for borough clerk and longtime Monmouth County clerk J. Russell "Brick" Woolley. His granddaughter is Janet Woolley Tucci, the mayor in 2006. Damon eventually bought a restaurant that he called Joseph's. It was converted from a farmhouse and was located on Monmouth Road between Route 36 and the Turtle Mill Creek. For several decades, the restaurant was known as Squire's Pub and was owned by another West Long Branch resident, Basil Plasteras. The property is now an elegant catering hall known as Branches.

Gertrude Poole, daughter of the borough's first mayor, Monroe V. Poole, married Howard Bradley on July 13, 1940, in the Old First Methodist Church, located near her childhood home on Cedar Avenue. The Reverend Harry R. Pine officiated. She worked as the secretary to Brick Woolley, who had also grown up on Cedar Avenue, and Howard was a buyer for Steinbach's Department Store. In 1990, Gertrude and Howard Bradley celebrated their 50th wedding anniversary at Old First, also known as the Mother Church of Methodism by people on the Jersey Shore. The congregation dates to 1809. In attendance at the Brick Woolley testimonial dinner of 1940, Gertrude remembered that the release of a live dove was part of the ceremony.

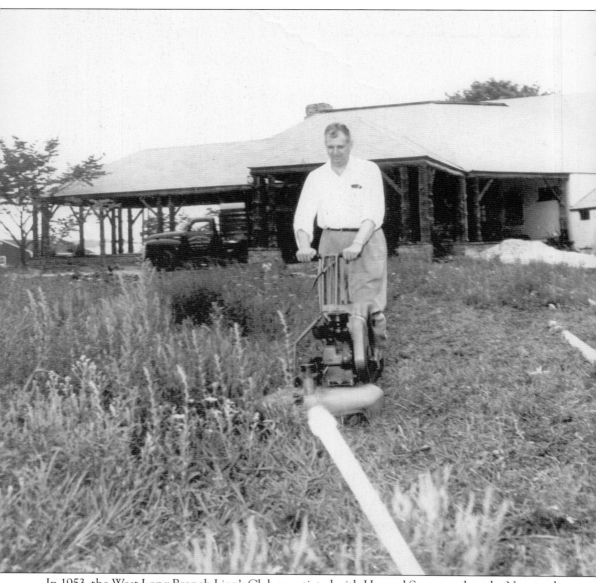

In 1953, the West Long Branch Lion's Club negotiated with Howard Strauss to buy the Norwood Country Club clubhouse, empty for about 10 years. The mortgage was $9,500. Here John Disbrow, a Lion's Club member, helps prepare the new community center for its first fund-raiser; the borough's population at the time was 2,740. Disbrow and his brother Harold operated Ray Croft, a chicken, feed, and farm supply business located on the east side of Whale Pond Road. They also ran Dee Bee Farms, a large-scale incubator business that raised baby chicks. In 1949, John was the bursar of Monmouth Junior College when it was located on Westwood Avenue in Long Branch.

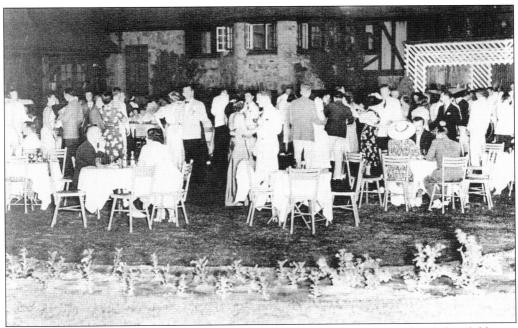

The club's Starlit Terrace, seen here with people dancing on the east side of the clubhouse overlooking Poplar Street, eventually gave way to the West Long Branch Public Library.

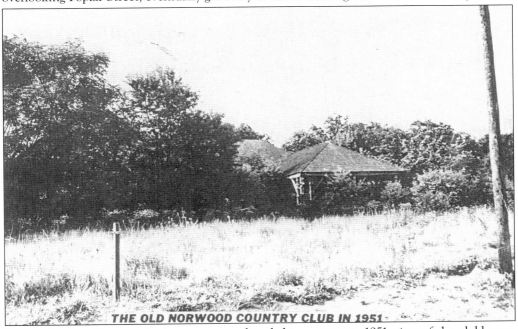

THE OLD NORWOOD COUNTRY CLUB IN 1951

Letting Mother Nature take her course produced this overgrown 1951 view of the clubhouse. Lynn Richards Steneck's aunt and uncle operated the Coleman Riding Stables on Brookwillow Avenue. She remembers being able to ride horses through the abandoned country club property, cross into Eatontown, pass the SPCA, cross Route 35, and arrive in the holly and scrub pine forest that predates the current office park now found on Industrial Way West.

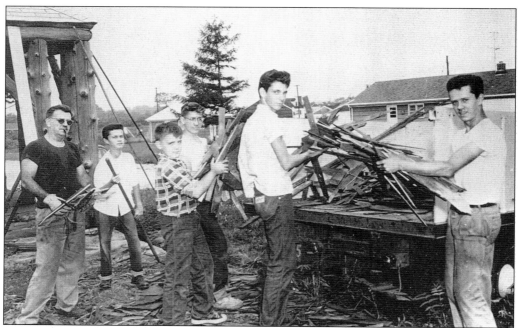

The borough's Boy Scouts help clean up the old clubhouse grounds. Picture are, from left to right, Joseph T. Welch, Woody Van Dyke, Howard Welch, Joe Welch, Dick Disbrow, and Stanley Van Dyke.

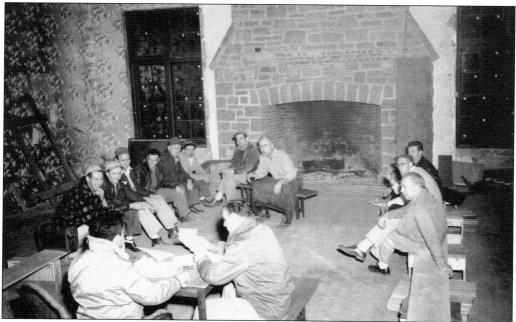

The Lion's Club held a board meeting to chart the progress of converting the clubhouse into a community center. They also discussed the need for municipal offices on the Poplar Street side of the property to accommodate the borough's postwar expansion and growing popularity as a spacious suburban community.

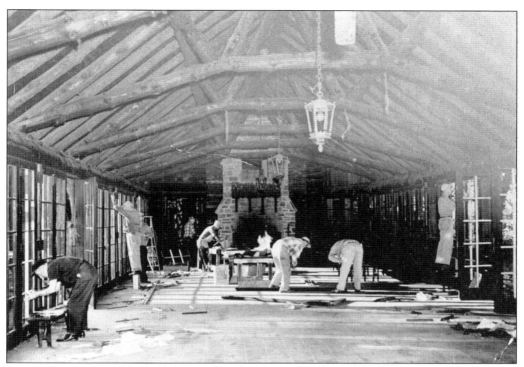

Interior renovation of the ballroom included getting rid of the wallpaper, putting in fire doors to the vestibule, and appreciating the oak timbers that created the rustic open ceiling.

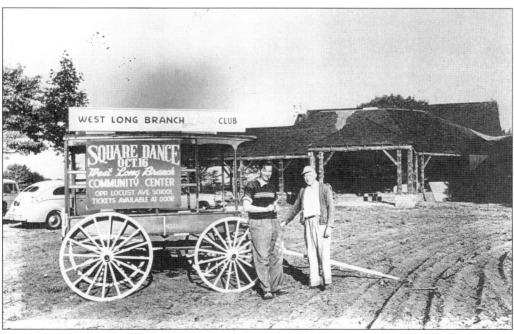

Seen here in this 1953 photograph, Lion's Club member Fred Metlar, with his ever-present pipe, is accompanied by another member of the community, just prior to a community center fund-raiser.

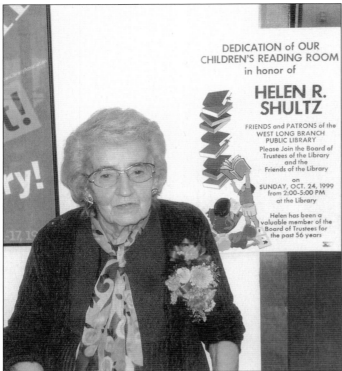

Looking for a book on Abraham Lincoln in 1946, Helen Shultz was invited to support the fledgling efforts of the public library. During 60 years as a trustee, Shultz saw the library grow from a small room shared with the post office to a modern facility. Shultz served 17 years as secretary, 25 years as president, and, after retiring in 1986, she returned to serve again as president from 1991 to 1994. Both the children's reading room and a library scholarship for college studies were established in her honor.

Trudy Pomerantz was devoted to the library for 30 years, both as an employee and as president of the Friends of the West Long Branch Public Library. The library celebrated its 75th anniversary in 2002 with the popular mystery writers Mary Higgins Clark and Carol Higgins Clark.

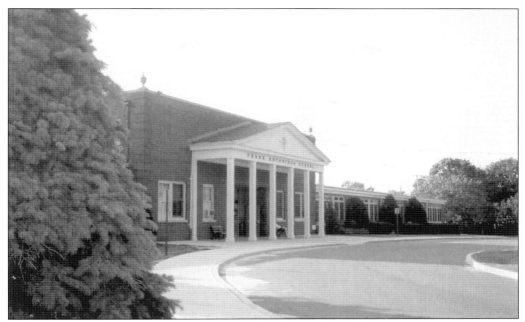

Built on the Louis and Laura Lane Farm in 1951, the borough's Locust Avenue Elementary School was renamed in 1958 to honor Frank Antonides, a longtime member of the board of education and two-term mayor. Antonides lived at 201 Locust Avenue until his passing in 1963. The school's architect was James Mancuso.

Eleanor Lane (Louis and Laura's daughter) and Frank Antonides celebrated their 50th wedding anniversary in 1952. Their daughter, Inez, married into the Dennis family.

Inez Antonides Dennis's daughter, Eleanor Dennis Hagerman, is flanked by her two sons, Bruce (with his son Bruce Jr. at left) and Brian. Brian served twice as fire chief of Engine Company No. 1.

Timothy Warren Hagerman, great-great-grandson of Frank Antonides and son of Brian Hagerman, stands with Larry Farley, school principal, at the 2006 eighth-grade graduation.

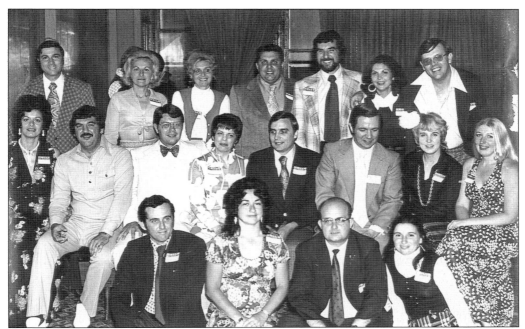

The eighth-grade class of 1953 was the first to graduate from the then-new Locust Avenue School. Seen at the reunion held in 1978 are the following: (first row) Peter Wortman, Carolyn Delapietra, Ed Roswell, and Beverly Schwortz; (second row) Martha Cosentino, Michael Addeo, Flavil "Spanky" Van Dyke, Ellen Burke, Mike Gareau, Eddie Phillips, Jackie Rohr, and Lillian Deming; (third row) Lenny Long, Joan Manzi, Suzanne Dischler, Frank Muccio, Greg Christopher, Carol Christopher, and Mike Fisher.

It was a sign of expansion in the new century when the borough hall's various departments outgrew their offices on Poplar Street. In 2002, borough hall was moved into the former Calvary Assembly of God church on Broadway, using the renovated sanctuary for the new council chamber and the Sunday school rooms and church offices for municipal offices.

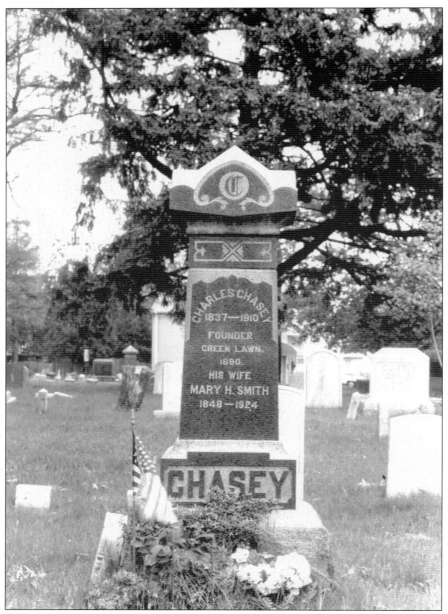

Located east of the new borough hall is the area's oldest nonsectarian graveyard, used initially by the city of Long Branch. Green Lawn Cemetery is the final resting place for a number of soldiers who fought in various conflicts, dating from the Civil War. Green Lawn also fronts part of the borough's well-defined neighborhood of Kensington Park, originally a working-class development between Broadway and what became Route 36. Charles Chasey lived on the north side of Broadway near Oceanport Avenue. Behind this cemetery are two of the three Jewish memorial parks located in West Long Branch. Mount Carmel Roman Catholic Cemetery is located on Wall Street. It is the other nonsectarian cemetery in Glen Wood on Monmouth Road. The borough's oldest Methodist cemetery is located on Monmouth Road. The second oldest is on Locust Avenue and Wall Street at Old First Methodist Church.

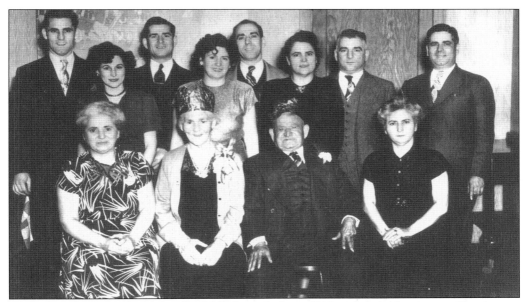

Lizabeth and Rocco Christafaro left Vallefierto, Italy, in 1911 and made their way to Kensington Park. Rocco found work as a caretaker for the Guggenheim family, and Lizabeth ran a little store at 70 Victor Avenue, where she sold mozzarella and pot cheese made with goat's milk. Here the now-Americanized Christopher family is gathered for the couple's wedding anniversary. Pictured are, from left to right, (first row) Mary, Lizabeth, Rocco, and Rose Olividotti; (second row) Anthony, Helen Grasso, Paul, Elizabeth Barbieri, Frank, Fannie Dorsi, Greg, and Dominick.

Christopher Brothers Plumbing and Heating was started in 1927 by Gregory, the first of the original Christafaro children to be born in the United States, and Gregory's brothers Anthony, Paul, and Frank. The firm is a father/son affair, and seen here in 1999, with Gregory's son Greg Christopher and Greg's own son, Keith, who operate the business on Victor Avenue.

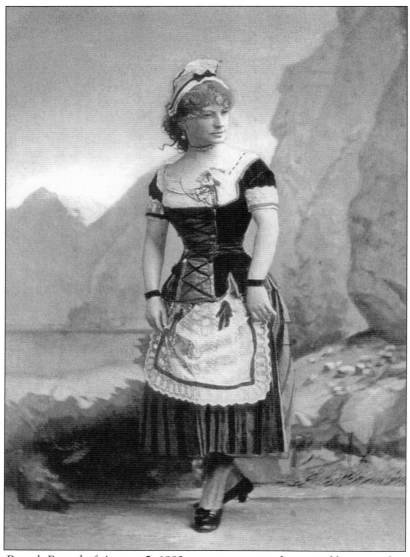

The *Long Branch Record* of August 5, 1883, reports a spirited game of lacrosse played by "the Thespians" on the grounds of the estate owned by Mrs. Henry T. Paddock. She was the actress Maggie Mitchell, best known for her starring 1861 role in *Fanchon the Cricket* (seen here), a lighthearted sentimental comedy based on a short story written by George Sand. While Cricket Lodge was located on Norwood Avenue, south of Park Avenue in Ocean Township, it was frequently a social setting for those theater families who lived on or near Cedar Avenue. This included Maggie's half sister, who used the stage name Mary Ann Lomax Mitchell. Mary had married actor John W. Albaugh, noted for having performed with Edwin Booth, founder of the Players, a club for actors on Gramercy Park in Manhattan. Albaugh later operated theaters in Albany, New York, and his home town of Baltimore. Also reported at the thespians' lacrosse party were H. T. and F. S. Chanfrau (whose house still stands on the northwest corner of Cedar and Elmwood Avenues), Julian Mitchell and Bessie Clayton, J. R. Albaugh, the William Hendersons, and William Hulick, a descendant of one of the original Long Branch–West Long Branch founding families who lived on the southwest corner of Cedar and Norwood Avenues.

Two

COUNTRY ESTATES ON AND OFF CEDAR AVENUE

A colonial carriage path to the sea from Monmouth Road, Cedar Avenue retains some of its country character to this day. It evolved as a residential corridor that was distinctly different from the sprawling 19th-century commercial hotels built east of Norwood Avenue, the boulevard that ultimately separated the Eatontown Township village from the city of Long Branch in 1904. Cedar Avenue's earliest notable residents were the descendants of the borough's original settlers who became successful farmers and local businessmen and those individuals with theater affiliations who lived in their country estates in the hot summer months when the unair-conditioned theaters were closed. One of the better-known New York theater owners of his generation was William Henderson, who managed the Standard Theatre on Broadway and 33rd Street in Manhattan where he premiered, among others productions, Gilbert and Sullivan's *Iolanthe*, or *The Peer and the Peri*, in 1882. In 1866, Henderson bought the Charles Hulick farmhouse that had been built in 1802. It was reported he spent $10,000 a year to maintain his summer cottage in "the Branch." Henderson called his gentleman's farm Rosedale, a popular 19th-century place-name as well as a lighthearted comedy written and performed by Lester Wallack in 1863 on Broadway. Farther west at 547 Cedar Avenue, Mary Ann Lomax Mitchell Albaugh died at the age of 75 on May 31, 1908, in the cottage of landscape architect Richard R. Hughes and his wife, Annie Van Note. Albaugh had first appeared on the New York stage in 1855 as Topsy in *Uncle Tom's Cabin* and then in Albany as Celia in *As You Like It* by William Shakespeare. She and her husband, John, spent 40 summers on the Jersey Shore following the close of the Civil War. The couple had just bought property from Abram T. Metzgar with plans to build a new summer home on Cedar when Mary died. Her half sister Maggie Mitchell Paddock Abbott survived her, as did her husband and children.

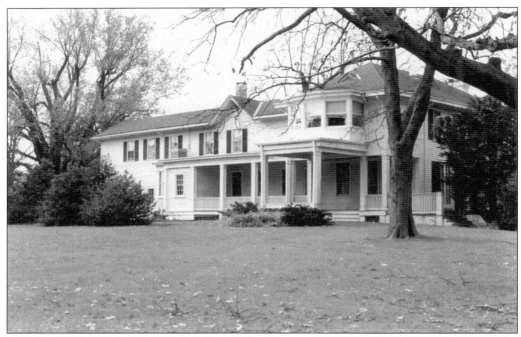

Rosedale was located on the south side of Cedar Avenue, opposite today's Pinewood Avenue. In the early 1920s, the property's new owners became Maurice and Lucile Pollak.

From the rear lawn, this view shows the modern extension added to the farmhouse where the Pollaks installed an interior swimming pool. Its interior perimeter was graced by lush potted plants.

The Pollaks named their property Marlu Farm. Lucile Pollak was an avid horticulturalist, having studied the discipline at Columbia University.

Here is a view of Lucile Pollak's formally designed garden. The couple also raised and showed championship terriers.

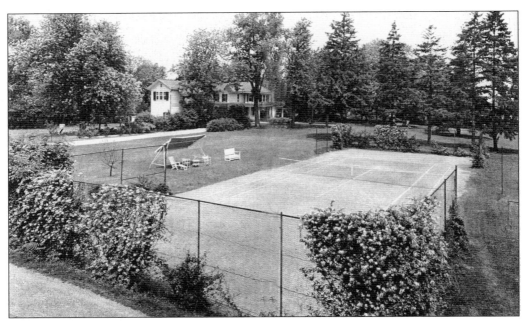

Here are the Pollaks' tennis courts.

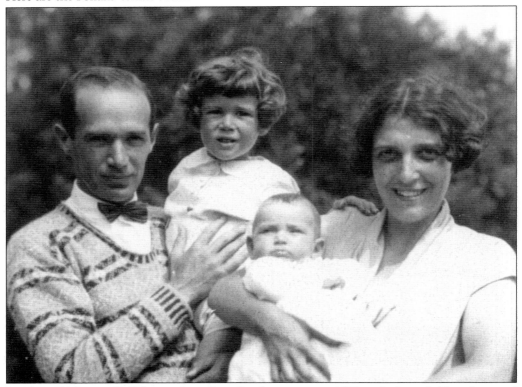

Lucile and Maurice Pollak pose here for a family portrait in 1925 with their children Lois and Henry. President of Henry Pollak Inc., a family business in Manhattan that imported raw materials for hats and knitwear from 1928 to 1958, Maurice later opened an investment office.

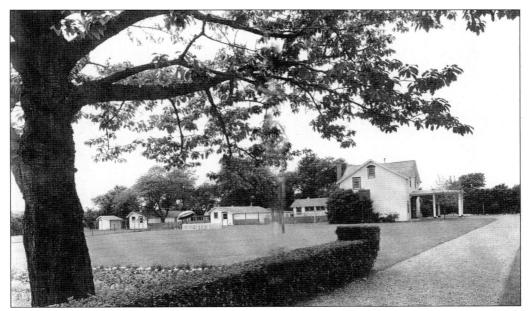

All that is left of Marlu Farm is this barn near the Monmouth University parking lot, which replaced the Hulick-Henderson-Pollak homestead.

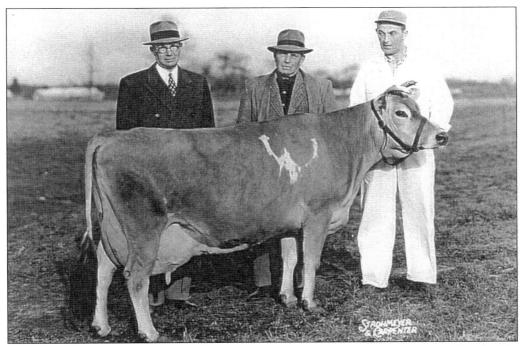

Here is Martin Pollak with his prizewinning dairy cow Marlu Milady. Between 1956 and 1964, she held the national production record for Jersey cows. The actual dairy farm was located on Newman Springs Road, overlapping the Lincroft-Holmdel border, west of the Geraldine R. Thompson farm. Today it is part of the Monmouth County Park System.

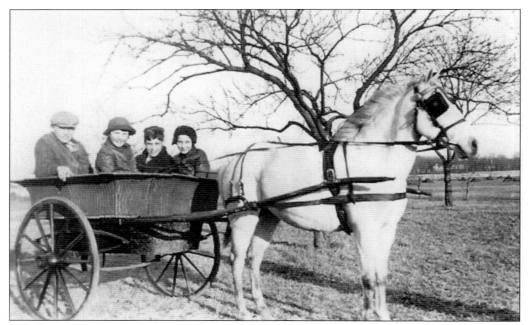

Another country estate on the south side of Cedar Avenue was the Meadows. Owned by Harold Spear Sr., the 21-acre property was located across from Monroe Avenue. In a carriage pulled by a beloved pony sits Harold Spear Jr., Nancy Spear Rossbach, and their cousins Henry Pollak II and Lois Pollak Stern Broder.

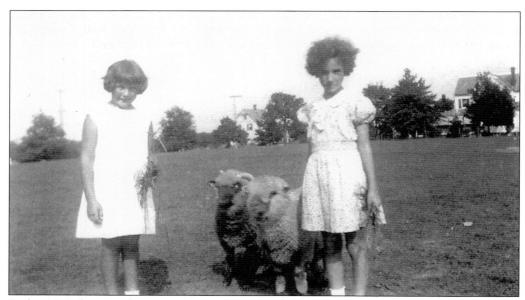

In this 1938 photograph, cousins Nancy Spear Rossbach and Lois Pollak Stern Broder feed sheep at the Meadows. In an earlier era, the property was known as the Metzger Farm.

Nancy Spear Rossbach is bundled up against the cold and snow of the winter of 1936. Built in 1896, the Meadows had been known as Buttonwood Farm when owned by I. T. Straus. Another inhabitant was the noted golfer Walter C. Hagen. In 1953, Mrs. Alfred Roberts, a horse breeder and trainer who also owned Renegade Farm in the then-named municipality of New Shrewsbury (today it is Tinton Falls), bought the estate. Roberts died of a heart attack at 39, never having moved into the house to which she had built an addition, bringing the total number of rooms to 23. The house and estate went through two more owners after Roberts: Chester Hirsch and Mr. and Mrs. Walter S. Lermer, who razed the house in 1961 after two years of trying to sell it.

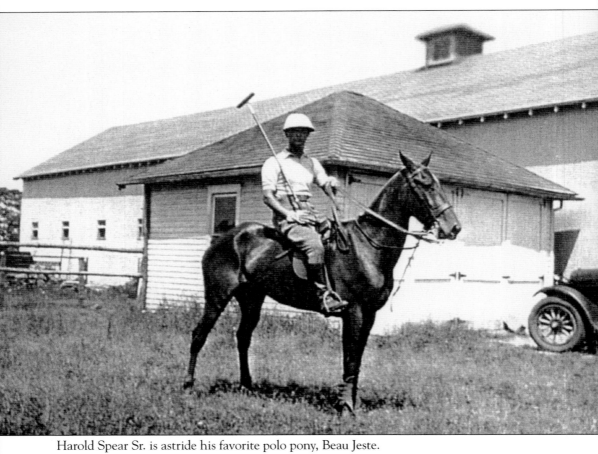

Harold Spear Sr. is astride his favorite polo pony, Beau Jeste.

The Lermers adapted the carriage house as a year-round residence, as seen here in the late 1990s, and retained 11 of the original 21 acres to raise horses. Two 150-foot lots were sold for modern homes east of 540 Cedar Avenue. The property's new owners became dentist Robert Isaacson and his wife, Barbara.

Au revoir. The last remaining horse farm in West Long Branch is seen here in the winter of 1996. In 2006, plans were drawn up to convert the farm to residential use.

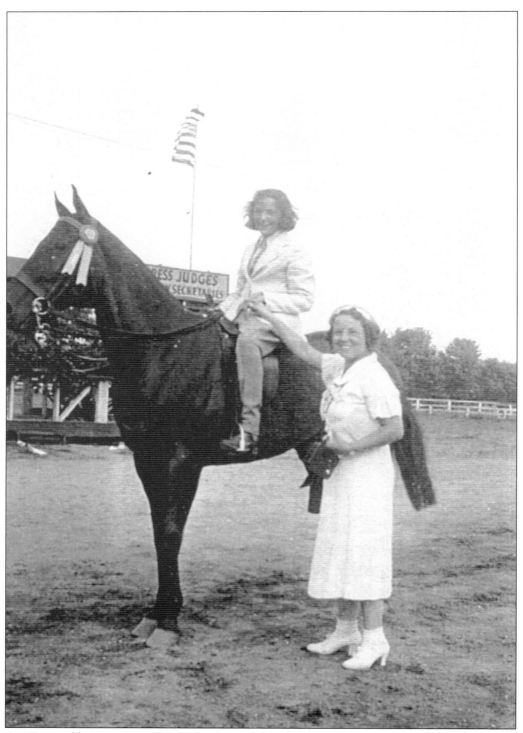

An 11-year-old Nancy Spear Rossbach sits astride Hot Chat at a local competition, with Beatrix A. Rochambault of Belgium.

From 1941 to 1949, Sterling Cheek Sr. was the caretaker of Raymar Farm, located on the southwest corner of Larchwood and Palmer Avenues and south to Whale Pond Brook. He is seen here in 1941 on a sulky with his son, Sterling Cheek Jr., who would later go on to be decorated with a Purple Heart for service to his country during the Korean War.

Named for Raymond Martin Cohen in 1938, Raymar was owned by Cohen's wife, Miriam. She is seen here with their two sons who were also avid horse riders. The family most likely lived elsewhere, perhaps in Elberon. Pip Sweeney was the property's next caretaker and was said to have maintained polo ponies on the property. Monmouth University now owns that remaining portion of the farm nearest the brook; the rest was developed into houses in the early 1970s.

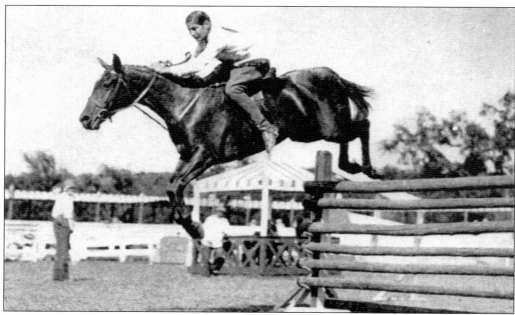

Harold Schiffer, whose family had a vacation home on Ocean Avenue in Elberon, was an experienced competitor in the tristate area. His parents were Samuel and Marion Schiffer.

Like her brother, Madeline Schiffer was an enthusiastic equestrian. During the week, the family, which also included their sister, Joyce, lived on Central Park South in Manhattan.

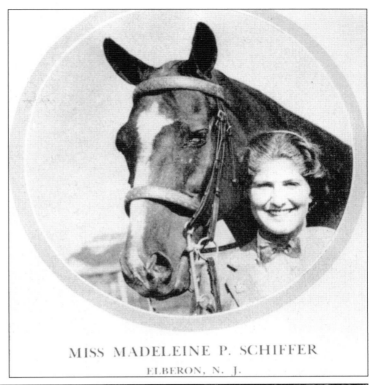

MISS MADELEINE P. SCHIFFER
ELBERON, N. J.

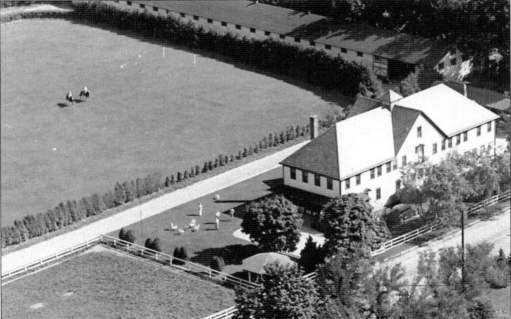

This aerial view shows Norwood Park's equestrian center on the north side of Beechwood Avenue, between Pinewood and Brookwillow Avenues. The acreage is substantial, occupying the entire block north to Hollywood Avenue. It would be last known as Kilkare Farm.

Here Joseph and Angela "Dolly" Iamello strike a pose while visiting Joseph's brother-in-law, Vincent Sacco, who trained show horses and then racehorses at Kilkare Farm. The two-story barn had space for show carriages on the first floor and two apartments on the second floor. The meticulously kept tack room featured trophies and ribbons from numerous competitions. Initially developed in 1916, the property also featured an indoor riding ring and pony track at one time. Family names associated with ownership are Tucker, then Stern. Quite possibly the third owner was Marion Schiffer-Weil, who named the property Kilkare Farm (after Marion married L. Victor Weil, she was known locally as Marion Schiffer-Weil). Upon her death, Kilkare was given to Arnold Funger, who was the horse farm's longtime manager. It is now the property of Monmouth University.

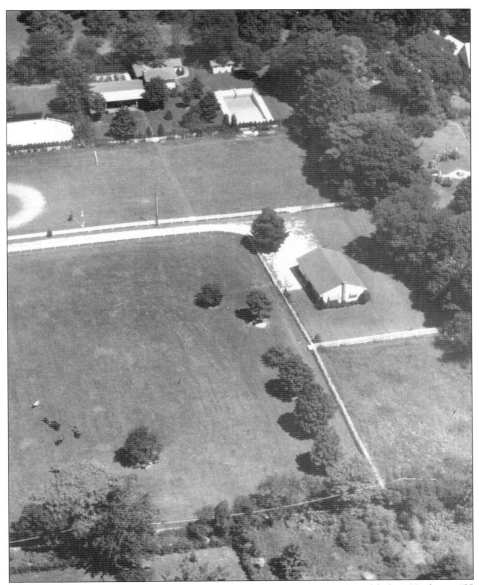

This is a 1950 aerial view of the country estate owned by New York publisher Kathryn "Kitty" Messner, located along the east side of Brookwillow Avenue. In the upper left is seen the original Messner house. Awnings dress the horse stable and its efficiency apartment. Lynn Richards Steneck recalls that it was here, during weekends in 1958, that Grace Metalious wrote *Return to Peyton Place* for Messner. Messner, a literary editor, received the publishing company after her divorce from Julian Messner, the original publisher of *Peyton Place*. The 1956 novel of infidelity, scandal, and secrets in a small town became a cultural touchstone of the postwar generation, spawning not only the sequel novel but also a television soap opera and various films. Actress Sandra Bullock is slated to star as the conflicted writer who died of cirrhosis of the liver in 1964. For a time, this end of the property, including the barn and the open pasture and excluding Messner's house, was known as "Peyton Place." Through the hedges at right is the Stanford White mansion.

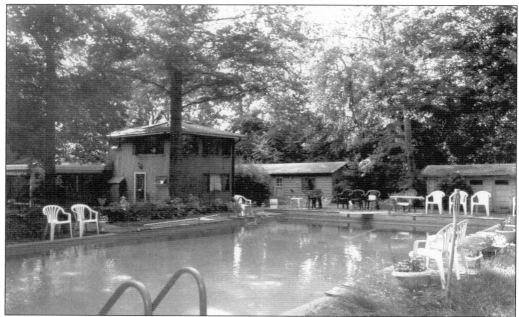

This is Kitty Messner's art moderne house, viewed across the borough's third outdoor swimming pool. Shadow Lawn had the first, and the Berger estate on the northwest corner of Pinewood and Hollywood Avenues had the second, remembers Lynn Richards Steneck. She later lived in the Messner house. Its new owners are Taka and T. M. Stevens. The latter is a heavy metal funk bassist, well known as a sessions musician who has also produced his own solo albums. In 2001, he had a part in the film *Limousine Driver*, for which he also wrote the sound track.

Though it looks similar to the original, this stable was added by Anthony Grecco when he bought "Peyton Place" and built the modern mansion that today occupies land originally used as cornfields. Grecco is best known as half of the partnership that created Paul Sebastian, a popular men's fragrance launched in the early 1980s. The estate's new owners are the Cojab family.

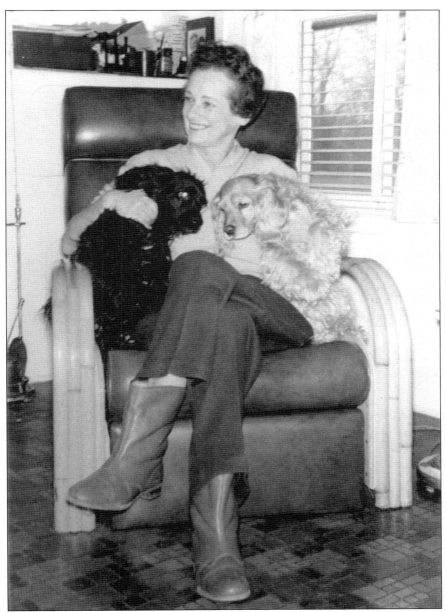

Kitty Messner poses here with two of her four dogs. Regarded as sophisticated yet down-to-earth, the Chicago-born Messner came down from Manhattan every Thursday and left on Sunday to return to her apartment in the Gladstone Hotel, remembered Steneck. She was fond of the outdoors, riding her horse, and keeping company with her dogs. In addition to *Peyton Place*, Julian Messner Inc. also published *The First Woman Doctor: Elizabeth Blackwell, M.D.* and *The Great Houdini, Magician Extraordinary*. Later, after Kitty Messner's death of breast cancer in 1964 and six months after Grace Metalious died, the company became a division of Simon and Schuster. Dr. Emily Toth details the relationship between editor and writer in her 1981 book, *Inside Peyton Place: The Life of Grace Metalious*. Reissued in 2000, it is the basis for the upcoming movie to be made by Sandra Bullock, for which the screenwriter is Naomi Foner Gyllenhaal.

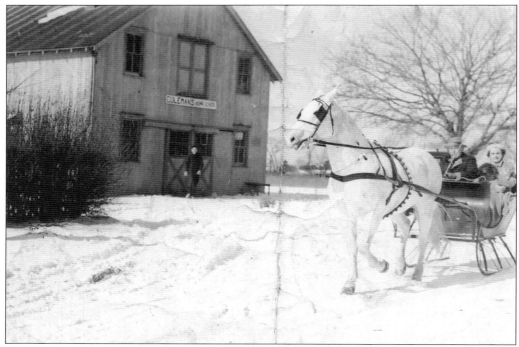

Otis Coleman and Dorothy Richards Coleman and their favorite horse Snowball are outside their riding stable on the southwest corner of Brookwillow and Maple Avenues, across from the country estate called "Peyton Place."

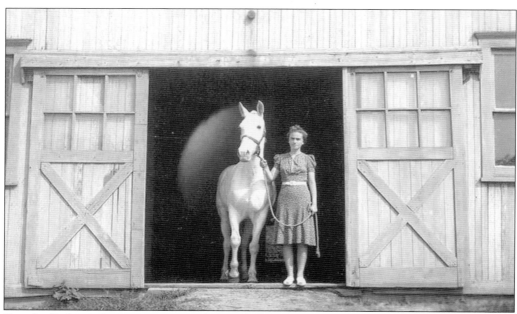

Dorothy Richards Coleman is seen with Snowball in warmer weather. By 1961, the barn was gone.

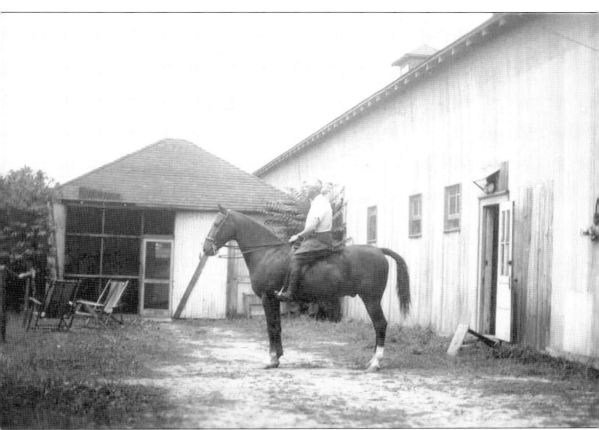

Otis Coleman is astride another one of the horses available for riding. For a time, many of the riders were students from the nearby Highland Manor School for Girls. The Colemans' niece Lynn Richards Steneck recalls the family using the abandoned fields of the Norwood Country Club to let their horses graze.

The original ranch house that was attached to the barn burned, but it was rebuilt. The newer two-story addition fronting Brookwillow Avenue was recently added by the Colemans' great niece and her husband.

Helen Herrmann attended Bryn Mawr College with Katherine Hepburn and was an outstanding mathematics major who later endowed a chair at her alma mater. She worked for Pres. Franklin Delano Roosevelt and also owned Baysholm Farm in Freehold Township. Herrmann maintained tennis courts in the borough at the foot of Brookwillow Avenue. She also played competitively at the Ocean Beach Club in Elberon. After donating her 71-acre cattle farm to the Monmouth County Park System in 1969, Herrmann moved into a house she had built near her tennis courts, overlooking Wall Street. There she played every day, remembered Pat Delahanty, a neighbor and frequent tennis partner. Among the guests to her new home was Katherine Elkus White, the first woman mayor of nearby Red Bank. Known for her philanthropy, Herrmann's bequest to CPC Behavioral Healthcare enabled the agency to open a counseling center in Middletown in 1993. She also established the Volunteer Center of Monmouth County. Her interest in mental health also had a West Long Branch connection. Her neighbor Robert Kastor, who lived on the corner of Cedar and Pinewood Avenues, started the Mental Health Association of Monmouth County. In the 1950s, Maurice Pollak started the county's first mental health clinic, establishing it at what is today known as Monmouth Medical Center in Long Branch.

SPECIAL EDITION.

Old Cap.Collier
LIBRARY.

0. 422.

MUNRO'S PUBLISHING HOUSE,
24 & 26 Vandewater Street, New York.—February 6, 1892.

5 Cent

Old Cap. Collier Library is Issued Weekly.—By Subscription $2.00 per Annum.
Entered according to Act of Congress, in the year 1892, by NORMAN L. MUNRO, in the office of the Librarian of Congress, Washington, D. C.—[Entered at the Post Office, N. Y., as Second Class Matter.]

CHILI'S CRIME;
OR,
THE YOUNG HERO OF THE BALTIMORE
The True Story of the South American Troubles.
By CAPT. WALTER WINSLOW, U. S. N.

THE BALTIMORE

WITH ALL HIS FORCE, THE CHILIAN HURLED THE ROCK DOWN ON THE HEAD OF THE YANKEE SAILOR.

In 1870, Norman Leslie Munro left the Beadle Publishing House in New York and founded his own imprint that put him squarely in competition with his already successful brother, George. Norman was interested in detective stories and achieved success with the publication of the Old Cap Collier Library, a series whose central character was an elderly though clever sleuth. Publishing was not Norman's only venture. In 1888, he began creating the borough's other well-defined neighborhood, second only to Kensington Park. The original plans called for 25 three-story cottages, a casino, tennis courts, and an equestrian facility. It is possible that Monroe Avenue at Norwood Park's western end was a misspelling of Munro. Its most famous resident, perhaps, was New York Life Insurance Company president John McCall. He is detailed in *Norwood Park: An Exclusive Summer Cottage Colony*, the well-researched history written by Robert J. Fischer. It was published by the West Long Branch Historical Society in 2000. The colony's chief architect was James Britton, a foreman for James Cloughy and Son (all from Long Branch) when the first Shadow Lawn mansion was built. Britton died in 1906. In addition to Norwood Avenue at the eastern end, the property was bounded on the south side by Cedar Avenue and on the north by Wall Street.

The northwest corner of Cedar and Norwood Avenues was a prime location for those who enjoyed visibility. For a time, thespians John Albaugh and Mary Ann Lomax Mitchell Albaugh lived on the corner. The next resident was Mary Anderson, who had made her New York stage debut in 1877 at the age of 18. Between 1883 and 1888, she was enjoying so much critical acclaim in London that she sold her summer cottage in 1886 to Norman Leslie Munro (seen above) and his wife, and they moved it. In its place the Munros built a handsome two-story wooden cottage with multiple gables, two turrets (one which anchored the house's southeastern corner), a center entrance, and a porch. The couple called the estate Normahurst after their daughter. In 1894, Munro died. In 1899, U.S. vice president and West Long Branch native son Garret A. Hobart rented Normahurst. In 1902, the estate house was lost in a fire. In 1903, Murry Guggenheim, whose family found its wealth in the copper mines of Colorado, bought the corner lot.

Norwood Court, found west off of Norwood Avenue, was built to accommodate the employees of Normahurst.

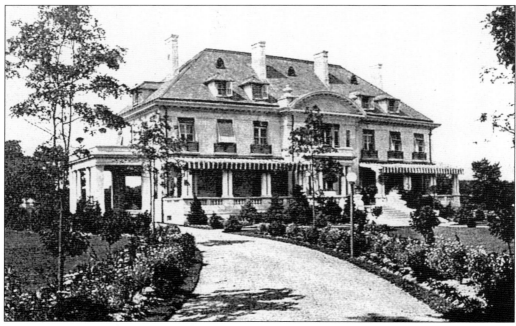

Neevastar-Lea was the name of the magnificent summer cottage owned by Leopold Stern, president of the Norwood Park Company that acquired a then-bankrupt Norwood Park. Stern's mansion was built on the northwest corner of Cedar and Brookwillow Avenues. Neevastar-Lea was later purchased by Eugene Lehman for his Highland Manor School for Girls and renamed Beechwood Hall.

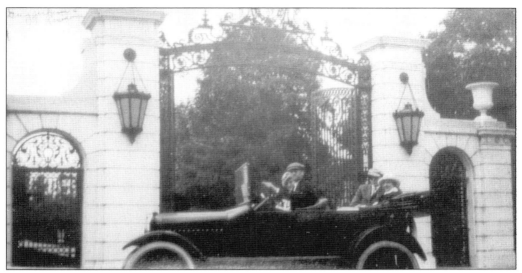

A dramatic focal point for those driving north on Norwood Avenue, the original gates to the Guggenheim estate on Cedar Avenue were a frequent backdrop for local photographs. Note the craftsmanship in the wrought iron, including the decorative MG. In 1998, the gates were replaced by a larger span and relocated off Cedar Avenue for better traffic sight lines. They now serve as the official entrance to the north campus of Monmouth University. The new scrollwork carries the initials MU.

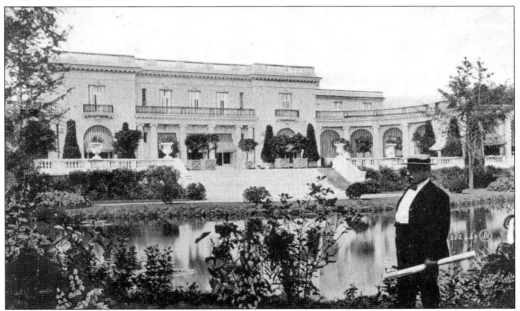

The Gilded Age had a number of famous building designers. Thomas Hastings and John M. Carrere, both of New York, were among the leading architects of the Beaux-Arts style and were retained by a number of well-to-do clients in Monmouth County. Their best-known edifice on the Jersey Shore, however, is the neoclassical summer cottage, designed for Murry and Leonie Guggenheim. The New York chapter of the American Institute of Architects awarded the partners the 1903 gold medal for this design.

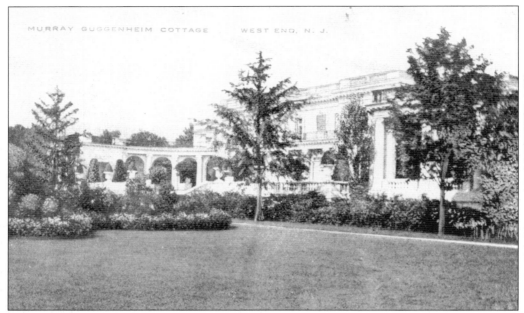

Completed in 1905, and with a 2006 restoration and addition to the university library, the public can still see this view of the mansion's formal front. A lawn replaced the pond. The university's library maintains a virtual tour online of all the rooms in the mansion and their original uses.

In addition to the landscaping on Cedar Avenue, the Guggenheims also had gardens, fountains, and statuary installed along the rear of their property. Italian immigrant Rocco Christopher was the estate's caretaker while English immigrant William Wagstaff was its horticulturalist. Wagstaff left the Guggenheims to work for Louis B. Tim in Long Branch, and then for New York nightclub owner Toots Shor. Shor had a summer home in nearby Deal, according to Walter Mischler, his grandson.

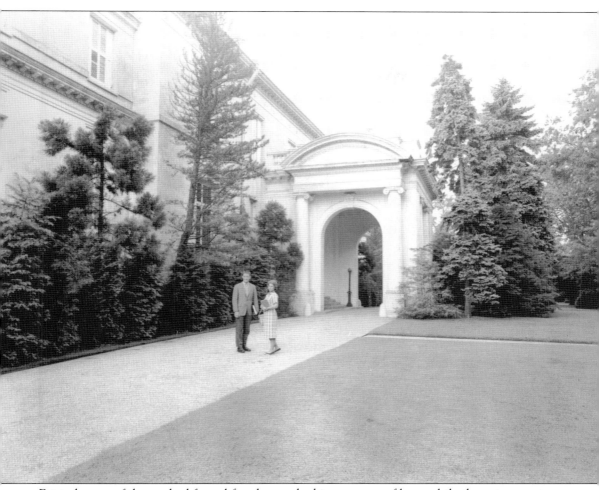

Estate houses of the era had formal facades overlooking a sweep of lawn while the entrances to the homes were in the rear, usually with a protective porte cochere large enough for carriages to pass through and passengers to alight. The Guggenheim mansion in this Dorn's Classic Images photograph is one of three remaining original estate houses in West Long Branch where that configuration is still visible.

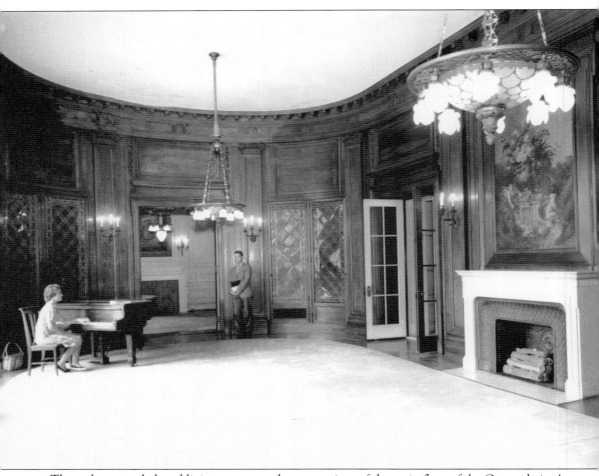

The walnut-paneled oval living room was the centerpiece of the main floor of the Guggenheims' mansion in this Dorn's Classic Images photograph. It is now the new circulation room for the university's refurbished library. Murry died in 1939 and Leonie continued to summer here until her death in 1959, when the estate became the property of a foundation in the couple's name. Initially the mansion was offered to Monmouth Memorial Hospital in Long Branch, but it was conveyed to Monmouth College in 1960 and formally dedicated as the Murry and Leonie Guggenheim Memorial Library in 1961.

Three

WEST OF WEST END, LONG BRANCH— NORWOOD AVENUE

Many performers and those who enjoyed an association with them were attracted to the West End section of Long Branch, a name that indicated the mid-19th-century influence of London theater on the American stage. It also defined the entertainment neighborhood of the five-mile-long popular seaside resort. Its main east–west thoroughfare was Brighton Avenue, with its western terminus at Norwood Avenue. Attracted to this neighborhood were vaudeville dancer Bessie Clayton and her husband, Julian Mitchell, a choreographer, director, and producer, who worked together off and on throughout their theatrical careers. In 1900, he staged *Fiddle-Dee-Dee*, a two-act burlesque musical extravaganza in which she performed. In 1902, he staged *Twirly Whirly*. In 1904, he directed her in an original musical comedy on Broadway titled *In Happened in Nordland*. In 1907, it was a two-act musical called *Hip! Hip! Hooray!*, and in 1908 was *The Merry Widow Burlesque*. Her last known performance was *The Passing Show of 1913* at the Winter Garden Theatre, a two-act music review in which one of the songs was "Ragging the Nursery Rhymes." The piece also included a cakewalk and the tangle-footed monkey wrench dance. Mitchell's more famous New York productions, however, were *The Wizard of Oz* in 1902 and *Babes in Toyland* in 1904, which wove together various characters from Mother Goose nursery rhymes. When the couple bought five acres on Norwood Avenue on which to build a summer residence, they hired noted architect, and theater aficionado, Stanford White to design a country cottage for them. White was a partner in the renowned architectural company of McKim, Mead, and White, regarded as the frontrunner among the nation's Beaux-Arts firms and responsible for mansions on Long Island's north shore, where he was from, as well as Newport, Rhode Island. The mustachioed White was a habitué of the Players Club and had a fondness for young girls. In 1906, White was murdered by millionaire Harry K. Thaw, who could not get over his actress wife Evelyn Nesbit having lost her virtue to White at age 16. White's great-granddaughter Suzannah Lessard wrote *The Architect of Desire: Beauty and Danger in the Stanford White Family* in 1996. A year later, Lessard was on hand when the Mitchells' home was a Monmouth County Junior League Designer Show House. Julian Mitchell and Bessie Clayton divorced in 1924, and he died in Monmouth Memorial Hospital in Long Branch in 1926.

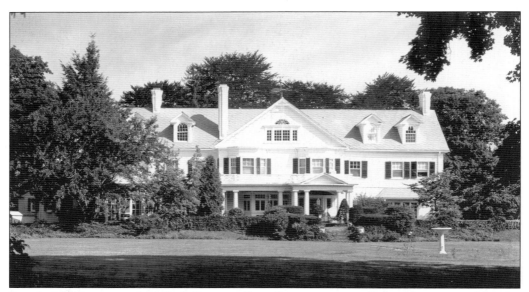

Stanford White gave the Mitchells a small performance area off the library, noted by the overhang (above right). French doors opened onto the terrace where the audience sat. If it were a substantial production, the audience sat on the front lawn while the terrace served as a stage. Curtains that framed the windows when in domestic use served double duty as theater curtains to indicate a change in scene.

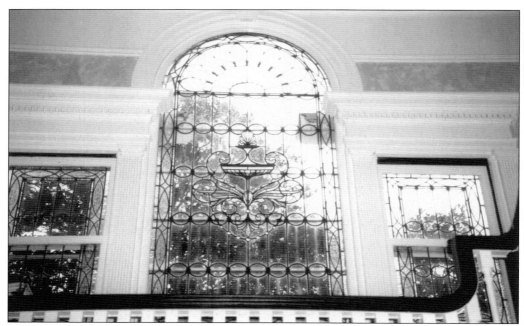

A substantial stained-glass window graces the second-floor landing that overlooks the porte cochere.

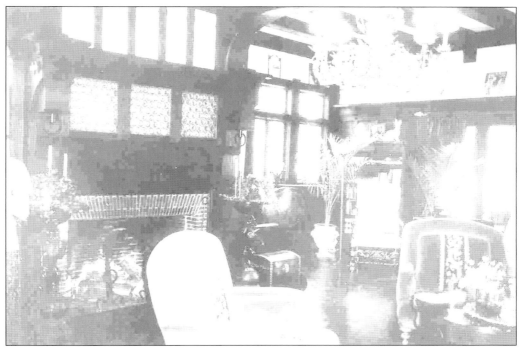

White's design principles were described as embodying the "American Renaissance." This is an interior view of the walnut-paneled library.

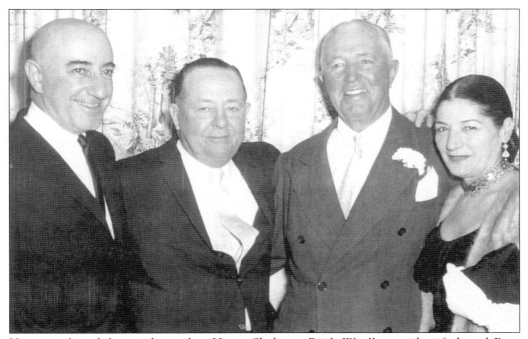

Here are, from left to right, realtor Henry Shaheen, Brick Woolley, unidentified, and Rose Shaheen. Henry bought the Stanford White–Julian Mitchell house for Rose in 1950.

Two legs sat upon three legs
With one leg on his lap.
 In comes four legs,
And runs away with
 one leg;

Up jumps two legs
Snatches up three legs,
Throws it after four legs,
And makes him bring
 Back one leg.

Stanford White typically separated bedrooms from hallways by a dressing-room foyer lined with closets so that an inner door and an outer door gave privacy. This was certainly the case in the placement of the nursery whose walls are lined in tiles from well-known children's rhymes. The Mitchells spent the summer of 1908 abroad, renting their cottage for a reported $4,000 to Jesse Straus of New York and his new bride. Straus was part of the R. H. Macy family. With his brother Percy, he was responsible for building the Macy's Department Store in Herald Square.

The Mitchells had one daughter, Priscilla. She married Roger Pryor, one of two sons of bandleader Arthur Pryor who lived until his death with his wife, Maude, on a farm off Wall Street in the western section of West Long Branch. Priscilla and Roger lived in the Stanford White house until their divorce in 1933.

White's shingled cottages featured double corridors so that a guest never bumped into a servant. This is another example of decorative work displayed at the Junior League Designer Show House.

Simple Simon went a-fishing
For to catch a whale
All the water he had got
Was in his mothers pail.

In 1915, Mitchell codirected the Ziegfeld Follies of 1915. The scenic designer was Vienna-born Joseph Urban. Urban also designed the Heart Building in Manhattan. In New Jersey, his best-known public work is the 1928 Gingerbread Castle in Hamburg, a fun house that reflected Urban's love of nursery rhymes.

Separately, but in the same guest book, Stanford White and Joseph Urban were visitors to Mar-A-Lago, Marjorie Merriweather Post's estate on Palm Beach Island, Florida. The only other known existence of these nursery tiles is in the nursery bathroom of the mansion now owned by New York real estate mogul Donald Trump and operated as a private club.

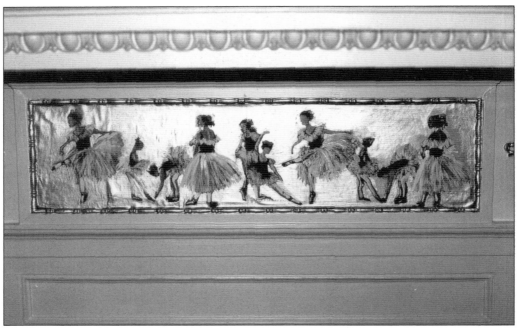

Another decorative element from the Junior League Designer Show House that pays homage to Bessie Clayton was done in the dining room by painter Susan Rosenthal.

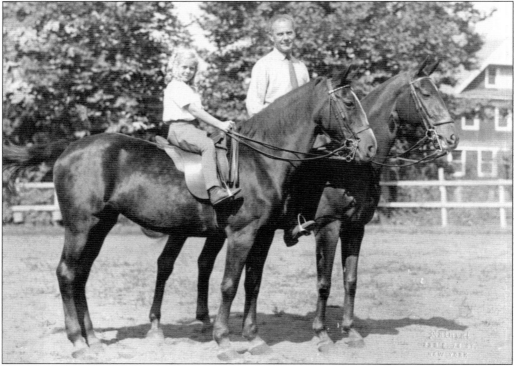

Here is Oscar Montulet with Katherine Brisco on Familla Lady in 1939. Oscar and August Montulet owned another local riding stable that also was frequented by the students of Highland Manor.

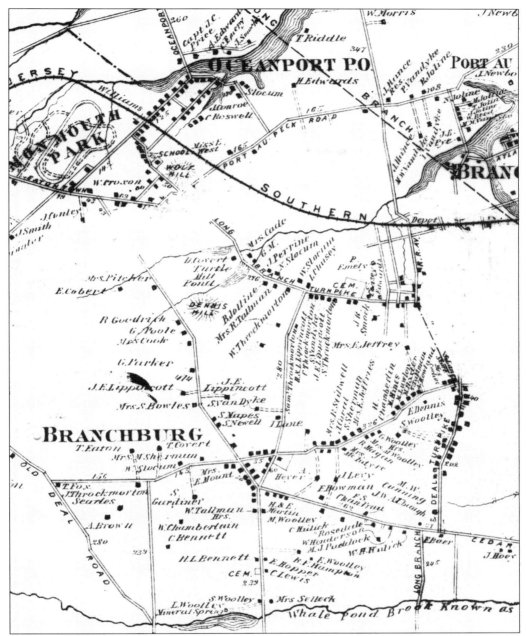

A portion of this 1873 Beers atlas shows the Norwood and Cedar Avenues farm estates, plus Wall Street landholders.

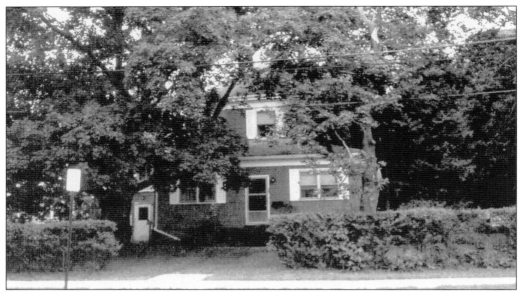

The Norwood Park Casino was the handsome centerpiece of the cottage colony bounded by Norwood, Hollywood, and Beechwood Avenues. A stunning Pach Brothers photograph of it may be found in *Those Innocent Years* by George H. Moss Jr. and Karen L. Schnitzsphan. When the lots were subdivided, the casino was physically reduced in stature and moved across Norwood Avenue from the southern boundary of the Stanford White–Julian Mitchell estate. It became a multifamily dwelling in Long Branch.

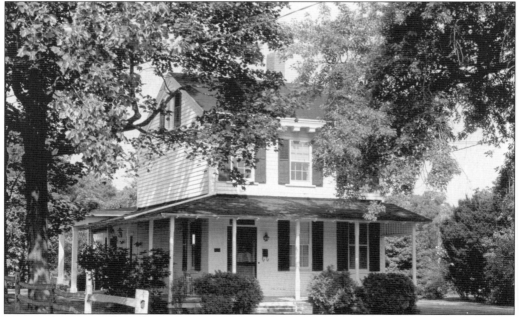

In 1893, the nationally acclaimed performer known as "the man who made Lincoln laugh" moved into this house on Norwood Avenue, north of the Stanford White–Julian Mitchell mansion. A relative with whom he lived, Maria Ward Brown, interviewed him and in 1901 published *The Life of Dan Rice*. It was released a year after he died at the age of 77.

Born in 1823 in New York, Dan Rice was the grandson of Richard Crum and Elizabeth Gardner Crum; Crum was a lay minister at Old First Methodist Church on Locust Avenue. Said to have liked rice pudding, Rice changed his surname from McLaren and signed up with a trained pig act in a traveling circus. Gifted as a song and dance man, storyteller, and joker, Rice toured the country with Dan Rice's Great Show.

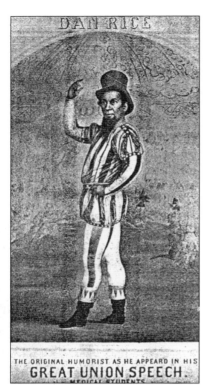

THE ORIGINAL HUMORIST AS HE APPEARD IN HIS
GREAT UNION SPEECH.

Was he or wasn't he the inspiration for political cartoonist Thomas Nast's Uncle Sam? David Carlyon examines this issue in his fascinating and exhaustively researched 2001 book *Dan Rice: The Most Famous Man You've Never Heard Of.*

Arthur C. Herry, a fifth cousin of Dan Rice through the matrilineal line that includes Maria Ward Brown, stands next to Brown's tombstone in Old First Cemetery where Dan Rice is also buried. Herry lives on Cedar Avenue in the J. D. Van Note house.

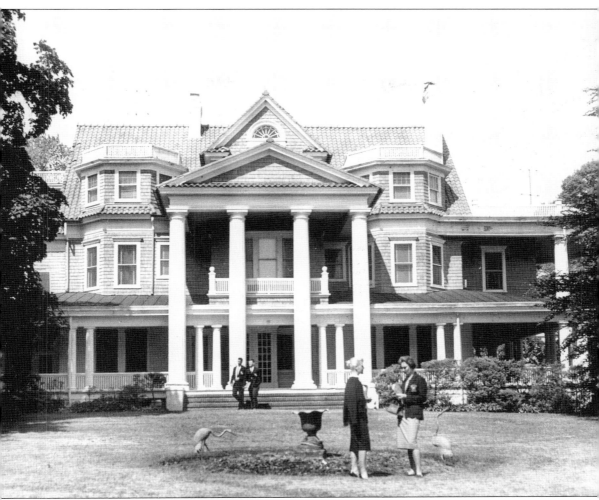

Brookside, immediately north of Whale Pond Brook, was the home of civil rights attorney Ira J. Katchen. His son, Julius, was a child prodigy at the piano. Eleanor Dennis Hagerman recalled listening to him perform at Long Branch High School. "It was clear he was a genius," she said, "We had never heard anyone like him." One of the defining moments of the young Katchen's career was performing two songs with the Rolling Stones in 1968 in London. The show was recorded for later use under the title *Rolling Stones' Rock & Roll Circus*. Sadly, Julius's promising career was cut short by cancer. In the early 1950s, Ira and his wife, Rita, were 2 of 82 members of the sponsoring committee of the much larger Monmouth College Committee for Shadow to raise funds to acquire the property across Whale Pond Brook from Brookside. In 1961, Monmouth College acquired the property and used it to house the education department. About 1980, the college received a $300,000 bequest from the estate of Victor E. Grossinger, a former Monmouth County freeholder who was instrumental in the establishment of the county park system, to help restore the former dwelling as the college president's home. It has since been torn down so that a modern residence for the university president could be erected.

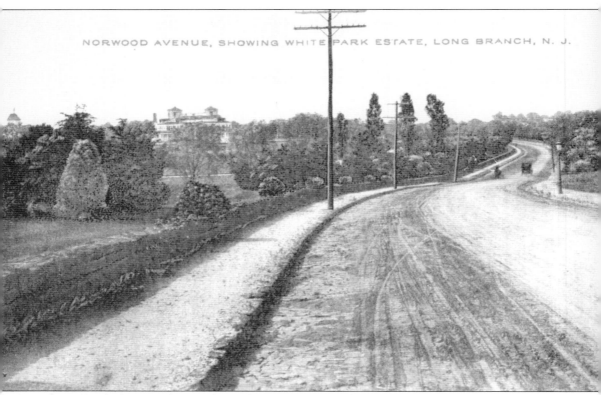

By 1910, the Norwood Turnpike was known as Norwood Avenue. This view, looking north from the Brookside estate at Whale Pond Brook, shows the sweep of the Great Lawn that was the "front yard" for the neighboring estate known as Shadow Lawn.

Four

THE SHADOW LAWNS

The cottage colony of Norwood Park was part of a trend at hotels from the Gilded Age: diversifying their accommodations with separate bungalows with housekeeping amenities. This addressed that category of traveling families who did not want, or could not afford, a separate vacation house that required servants for staffing while still offering private settings with hotel services for shorter periods of time than an entire summer. East of Norwood Avenue, along the north side of Cedar Avenue, the most well-known property was the Hollywood Hotel and Cottages. In a 1917 brochure printed by the Department of Publicity in city hall, Long Branch, the copy proclaimed,

> The resort's charm is . . . its cottage life, amplified by first class hotels . . . there are 100 miles of fine roads available for automobiles and these drives run throughout the most beautiful cottage colony in America. Every attraction known to the lover of outdoor life is here amplified. Golf courses, modern clubhouses, tennis courts, large swimming pools, and good fresh and salt water fishing. No city the size of Long Branch can present such a record of heathfulness.

The Hollywood Hotel Association also had a nine-hole golf course on the south side of Cedar Avenue and leased the property to the Hollywood Golf Club for three seasons from 1898 to 1902 when the club relocated to Locust Avenue in West Long Branch. The hotel maintained the golf course until the late 1950s when it was eventually subdivided with ranch homes. Hollywood's lushly landscaped grounds provided an appealing vista for the residents of the northwest corner of Norwood and Cedar Avenues. Seeking to move out of the more intimate neighborhood of Norwood Park and looking to make a statement that befit his professional achievement, New York Life Insurance Company president John McCall commissioned architect Henry Edward Creiger to come up with a summer home large enough for his extended family that was "suggestive of the grandeur of the Alhambra, the Petit Trianon, and San Souci." Creiger designed a large three-story architectural pastiche of neocolonial and Victorian styles, first-, second-, and third-story porches, attached gazebos, and a third-floor roof atrium flanked by fireplaces covered with still more porches to look like twin lookout towers. Its imposing semicircular front portico looked south over sculpted terraces and an expansive front lawn rolling the length of Norwood Avenue to Whale Pond Brook.

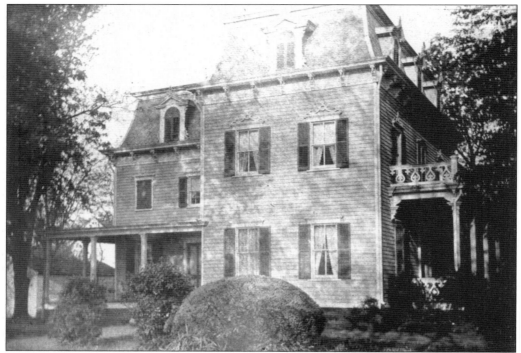

This is possibly the original Hulick farmhouse on the southwestern corner of Norwood and Cedar Avenues. In 1902, John McCall acquired not only the 27-acre Hulick property but also 15 acres and a house from Mrs. Charles Abbott, plus 10 acres on Cedar Avenue from Ettie Henderson. The Shadow Lawn estate at that time comprised 65 acres.

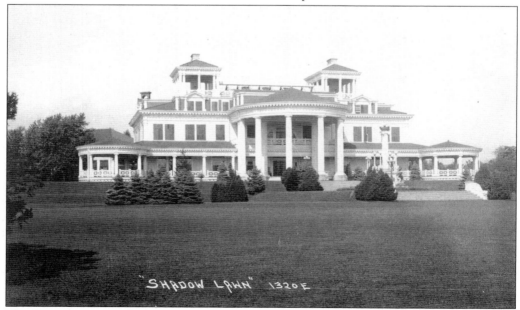

The 52-room mansion had a separate two-story carriage house with a windmill and water tower. Both were built in 1903, and the McCalls could have moved in on August 15.

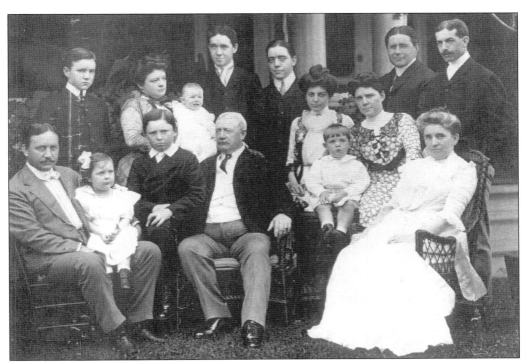

The McCall family poses here in 1902. Pictured are Darwin P. Kingsley, Hope Kingsley, Clifford Hyde McCall, John A. McCall (seated fourth from left), Darwin Pearl Kingsley Jr., Mary I. McCall, Sydney C. McCall, Louise McClare McCall, John Chapman McCall, and Albert McClare.

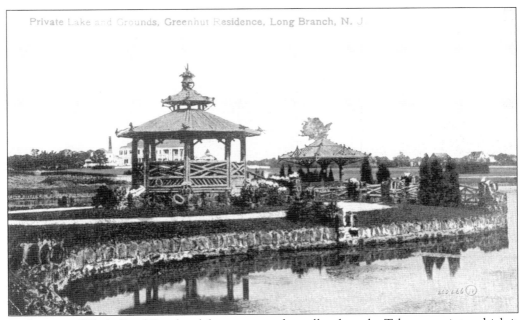

Private Lake and Grounds, Greenhut Residence, Long Branch, N. J.

By damming Whale Pond Brook, a lake was created, smaller than the Takanassee into which it empties. It was anchored by a rustic gazebo.

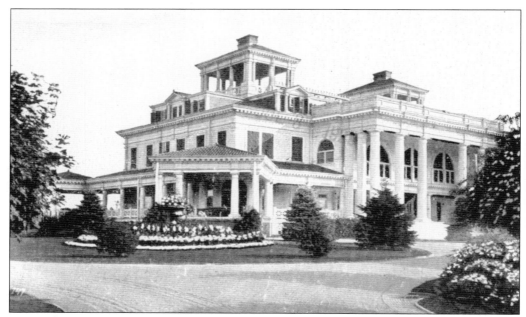

Here is the rear, or north, facade of Shadow Lawn. In 1905, the life insurance industry underwent an investigation led in New York State by special legislative counsel Charles Evans Hughes. Caught in fiscal improprieties that included bribing state officials, an ailing John McCall announced his resignation. He died the following February at the Laurel Hotel in Lakewood.

The breakfast room might have been located on the mansion's east side to take advantage of the morning sun.

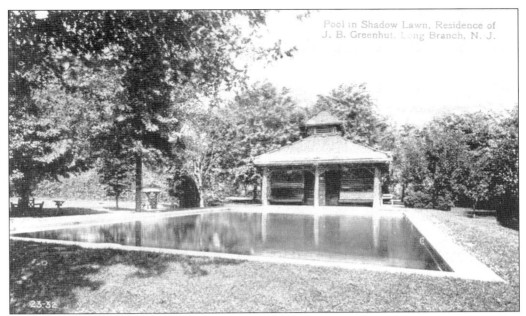

Shown here is the first inground swimming pool in West Long Branch on the mansion's north side.

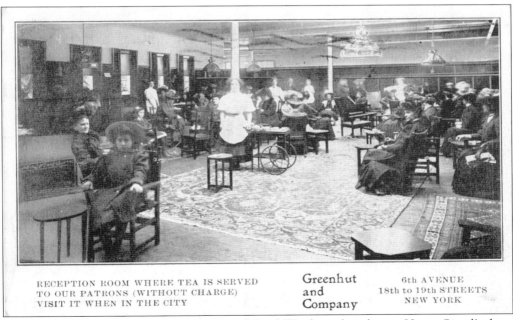

Illinois-bred Joseph B. Greenhut, a decorated Civil War hero, bought out Henry Siegel's share of the Siegel-Cooper Department Store in 1902. In 1909, Greenhut purchased Shadow Lawn for $1 million and encouraged its use as the "summer White House." Pres. Woodrow Wilson made a dramatic acceptance speech from its flag-festooned portico after the Democratic Party nominated him to run for a second term in 1916.

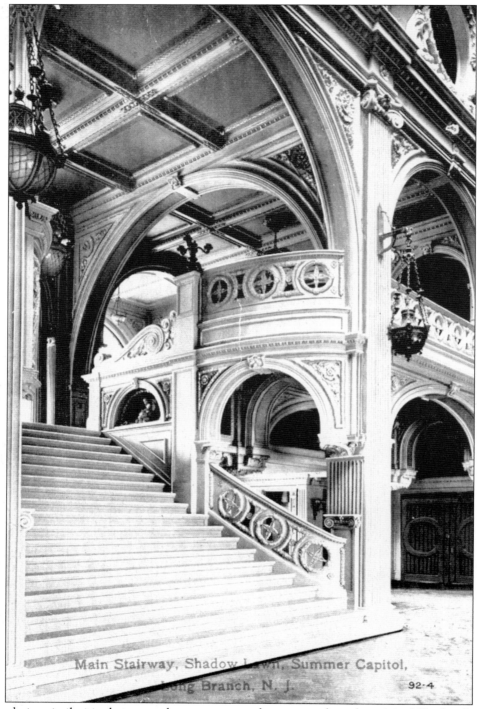

Main Stairway, Shadow Lawn, Summer Capitol,
Long Branch, N. J. 92-4

The design similarities between what was promoted on postcards as the original Shadow Lawn and the one recognized today are unmistakable. The original staircase to the mezzanine was 25 feet in width.

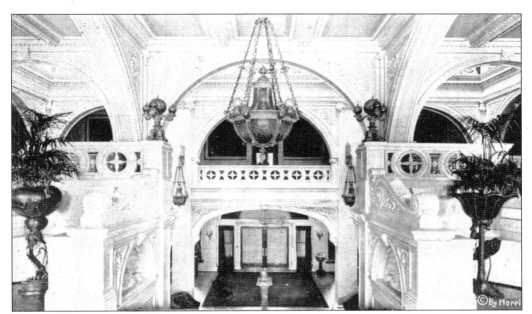

The main hall was 70 by 80 feet and 60 feet in height.

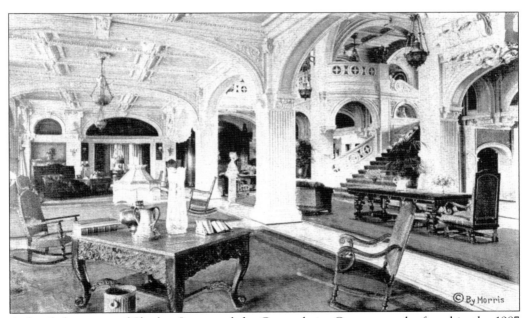

A detailed account of Shadow Lawn and the Guggenheim Cottage can be found in the 1987 pamphlet *Crossroads Mansions*, researched and written by Guggenheim Library director and borough resident Robert Van Benthuysen. Upon his passing, his collection of Jerseyana research, including his written contributions on Jersey Shore history, went to the West Long Branch Public Library.

By 1915, Joseph B. Greenhut's department store was ailing, in part because of a decline in its mail-order business, the flight of department stores uptown that left fewer shoppers downtown, and the anticipation of the United States' entry in World War I. In 1918, Greenhut died, and the family sold its summer home for $800,000 to Hubert Templeton Parson, another member of Manhattan's retail industry. The Canadian-born Parson went from being a bookkeeper for F. W. Woolworth to succeeding him as company president. Many regarded him as the son Woolworth never had, initially indulging his construction of a new mansion on the Jersey Shore that echoed the grandeur of Woolworth's own Beaux-Arts mansion in Glen Cove, Long Island, designed by Cass Gilbert. Hubert and Maysie Parson were not in residence on January 27, 1927, when they received word that Shadow Lawn was destroyed by a fire of undetermined origin. The $1 million restoration of the Greenhut mansion had included an estimated $1.25 million in furnishings for which the Parsons collected a mere $579,000 in insurance. Nonetheless, Parson rebounded from the fire by hiring Philadelphia society architect Horace Trumbauer, commissioning him to design a fireproof edifice that would resemble Versailles, the opulent 17th-century baroque palace designed for France's Louis XIV, the Sun King.

Detail of the elaborately decorated Woolworth Tower in lower Manhattan where Parson worked is seen here. The architect was Cass Gilbert. The 60-story building boasted 87 miles of electric wiring, 53,000 pounds of bronze and iron hardware, and 12 miles of marble wainscoting. On April 24, 1913, Pres. Woodrow Wilson pressed a button in the White House to illuminate 80,000 lights on the "cathedral of commerce" to signal completion of the $13.5 million headquarters.

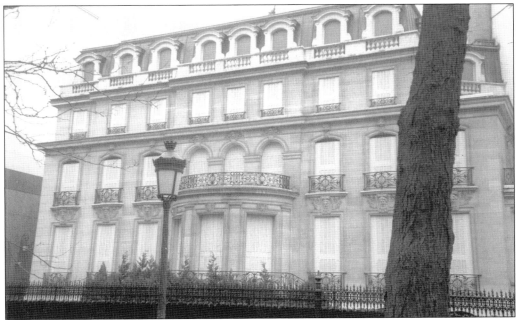

Hubert and Maysie Parson maintained a home on the exclusive Avenue Foch in Paris, seen here in a photograph taken by the author in 1996. By all accounts, it was Maysie who was the ardent Francophile whose desire for acquisitions and social acceptance would lead to financial trouble later on. The couple also had a private house on Fifth Avenue.

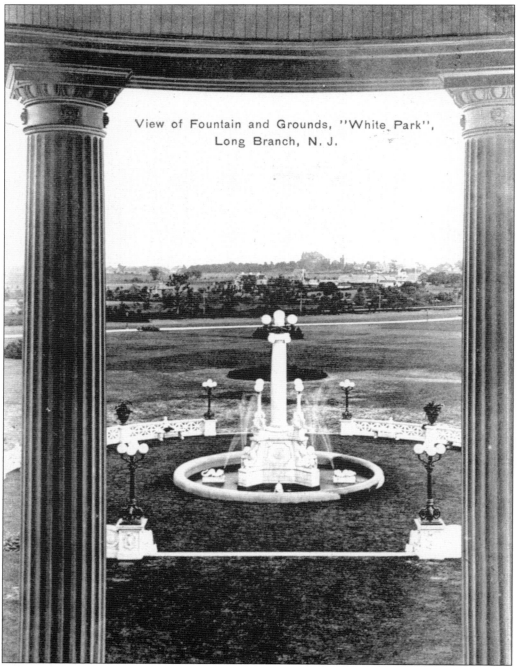

View of Fountain and Grounds, "White Park",
Long Branch, N. J.

Between John McCall and Joseph B. Greenhut, Shadow Lawn had two other owners, New York lawyer Myron T. Oppenheim and Abraham White, president of the DeForest Wireless Telegraph Company. White renamed the property White Park. This basin and electrical torchiere may have survived the 1927 fire but could have been sold at the estate's auction in 1940.

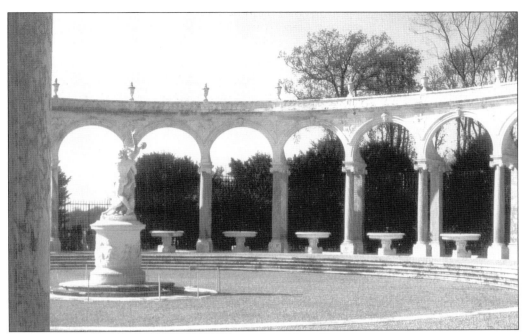

This is an image of the Bosquet de la Colonnade at Versailles.

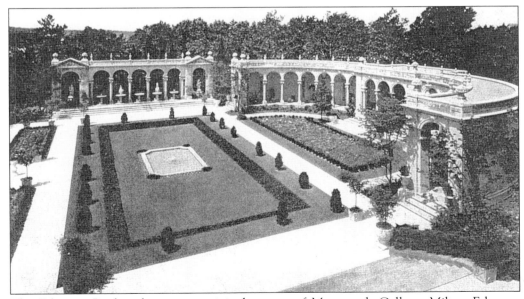

The Erlanger Gardens honors an original trustee of Monmouth College. Milton Erlanger, president of B.V.D. Corporation, owned a gentleman's farm on Park Avenue, south of Whale Pond Brook. His wife, Alene, a highly regarded breeder of miniature and standard poodles, further distinguished herself by helping to train dogs for the U.S. Army during World War II.

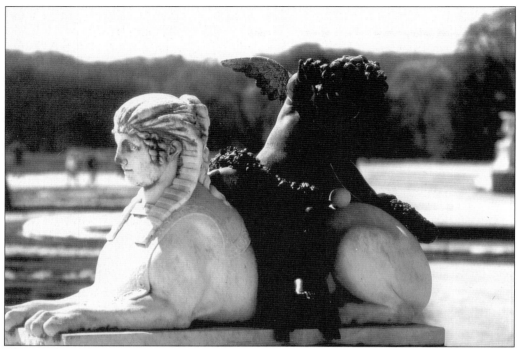

The angel and the sphinx at Versailles are among the more photographed statues in the palace's formal gardens.

Horace Trumbauer's design assistant on the new Shadow Lawn was Julian Francis Abele, the country's first African American professional architect.

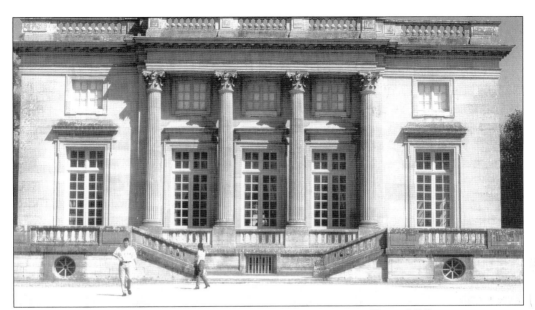

This is the Le Petit Trianon of Marie Antoinette, queen consort of Louis XVI.

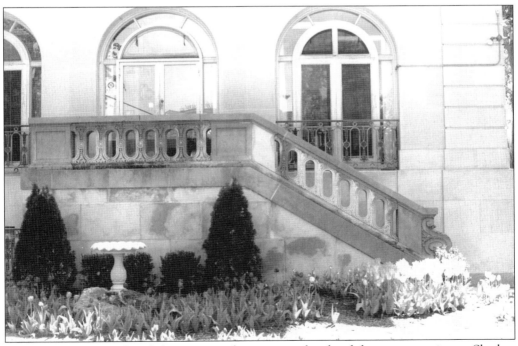

The design elements found their way to the entrance facade of the servants wing at Shadow Lawn. During the early days of Monmouth College, the bookstore occupied the bottom two floors. The top residential floors were converted into offices for various departments, including history, English, and foreign languages.

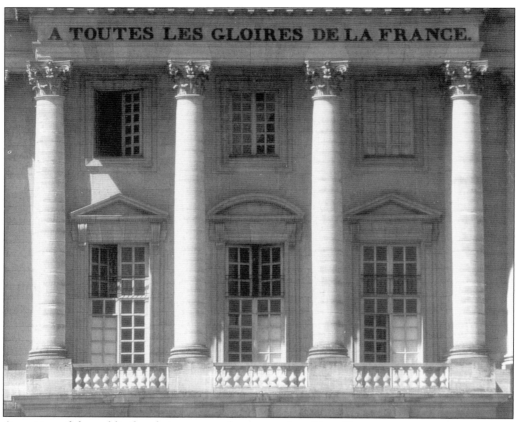

A portion of the public facade is seen on the approach to Versailles.

The public, or north, facade of Shadow Lawn is seen here from Cedar Avenue, with its impressive Ionic capitals. The mansion's overall construction incorporated steel, concrete, limestone quarried in Belford, Indiana, and 50 varieties of Italian marble.

Marie Antoinette had a belvedere in her Versailles garden for serving tea.

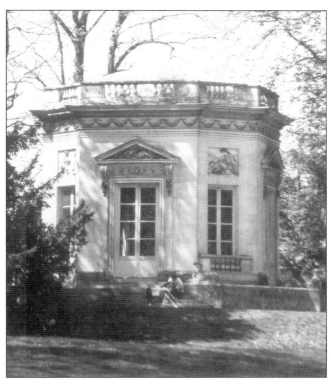

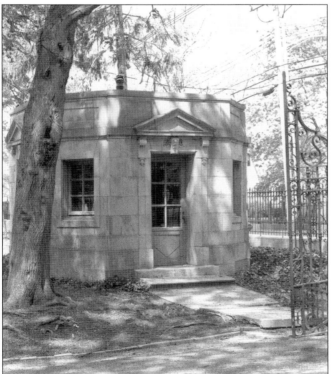

The Horace Trumbauer–Julian Francis Abele team found a way to reinterpret the belvedere as Shadow Lawn's gatehouse on Cedar Avenue. Whether one arrived or left from Cedar or Norwood Avenues, the porte cochere was located on the mansion's east side, leading into a marble-paneled foyer.

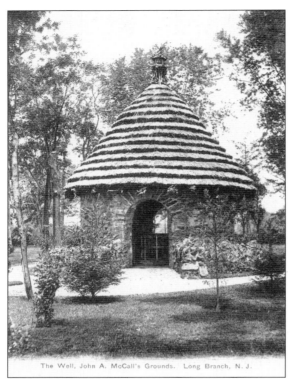

The Well, John A. McCall's Grounds. Long Branch, N. J.

Landscape architect and once borough resident Richard R. Hughes received the commission from John McCall to design this wishing well. A native of Wales, Hughes knew how to thatch a roof, and family history says he thatched this one. The wishing well escaped the 1927 fire. Richard and Annie Van Note Hughes were living in Atlantic Highlands while Richard implemented his design for Scenic Drive along the bluffs when retired actress Mary Ann Lomax Mitchell Albaugh died in their West Long Branch home. The Hughes house is now the home of Leeann Herry Arnts, a Van Note–Hughes descendant, and her husband, Robert.

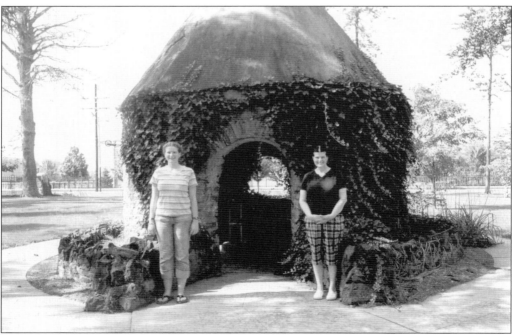

Alice Rose Arnts Griffin (left), class of 2001, and her mother, Leeann Herry Arnts, class of 1978, were Hughes descendents and both studied music at Monmouth College. The well's original thatched roof has been replaced by a concrete one.

82

With the stock market crash of 1929, Maysie Parson's extravagance came to an end, and four years later in 1932 so did her husband's $650,000 Woolworth salary when he reached the company's mandatory retirement of 60. His company stock depreciated as well. By 1937, the borough was threatening to cut off sewer services to the property unless the Parsons paid their taxes, in arrears since 1933. The mansion comprised 130 rooms on three main floors, plus rooftop and lower-level rooms. There were 17 master suites and 19 baths. Each of the baths was decorated and furnished in a different period and had gold-plated or silver-plated fixtures. Covering the parquet floors were 60,000 square feet of carpeting and 146 rugs specially designed and loomed in Europe and Asia. It took four years to complete the order. When the estate was put up for auction in 1939 the only bidder was the borough. Its "winning" bid: $100. It was far too expensive to heat in the winter to attract any interested bidders. The following year, most of the contents of Shadow Lawn was auctioned off, going for considerably less than what the Parsons had paid for them.

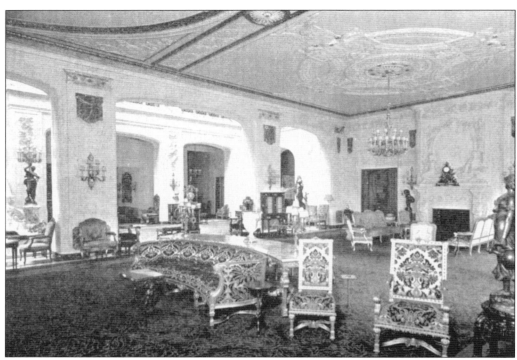

Here is a view of the Great Hall.

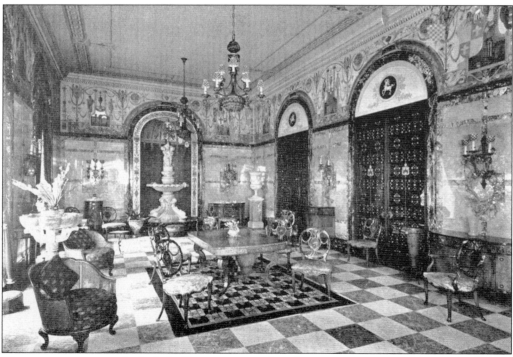

The conservatory overlooked the Bosquet-inspired garden.

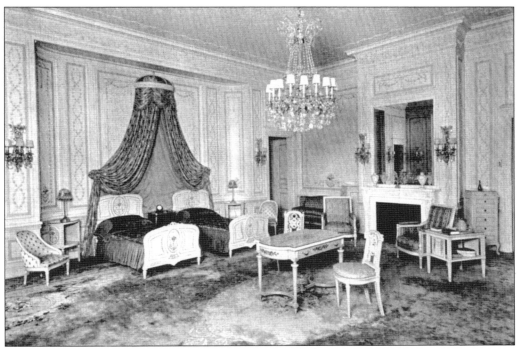

Here is what the auction catalog called the Louis XVI bedroom.

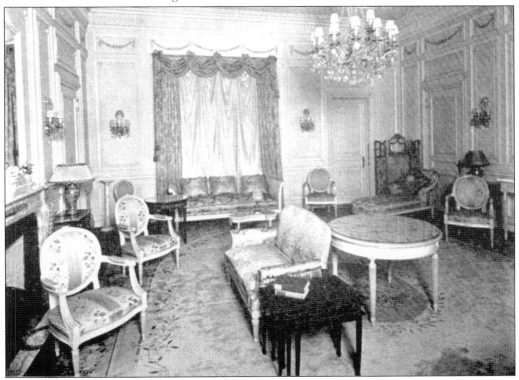

The French-inspired theme continued in the Marie Antoinette sitting room.

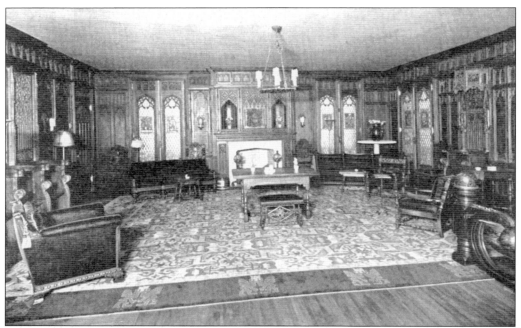

Sometimes referred to as the mansion's chapel, the auction catalog identified this room as an English lounge.

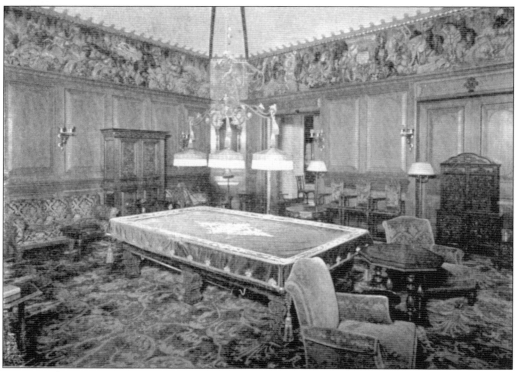

One wonders if the Parsons ever used this lavishly decorated billiards room.

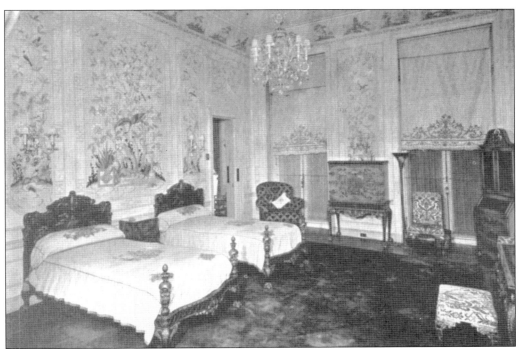

So many bedrooms, so many decorating styles. Pictured is the Chippendale bedroom suite.

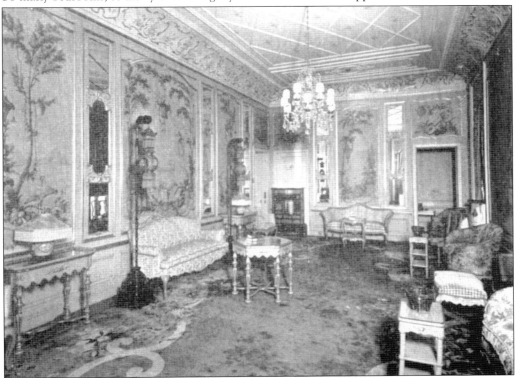

According to the catalog, this was a Chinese boudoir.

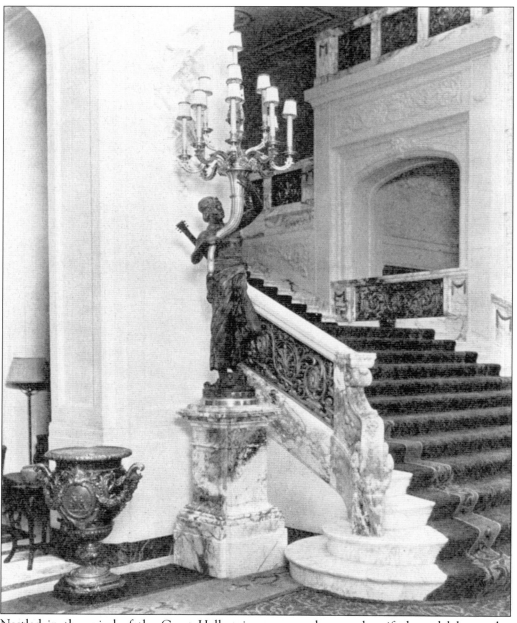

Nestled in the spiral of the Great Hall staircase was a bronze electrified candelabra and a Louis XIV Sienna marble urn.

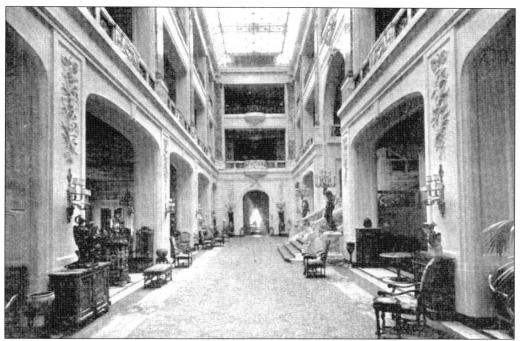

Entry to the Great Hall from the marble lobby off the porte cochere is seen here. A rug woven in the Canary Islands and measuring 24 by 93 feet covered the floor.

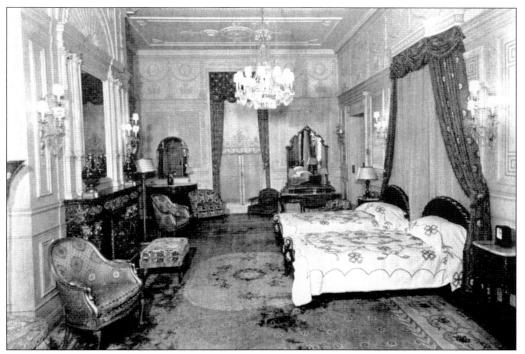

This Directoire-inspired bedroom is an example of the transitional style of decorating between the luxury of Louis XVI and the severity of the empire.

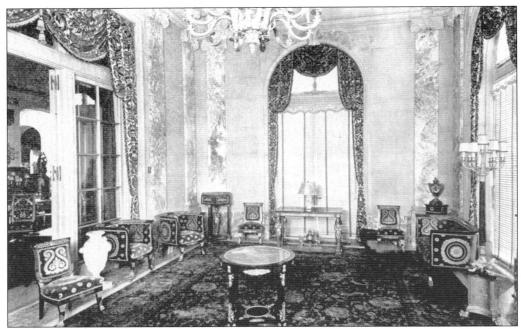

The Empire-inspired loggia that overlooks the Great Lawn is still used today for classes and conferences.

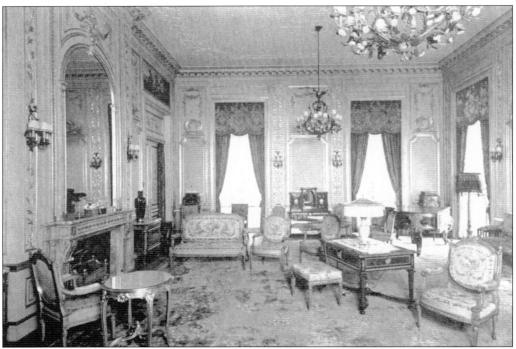

The concept of a morning room was to provide a place to entertain callers before noon, and it was located on the mansion's east side.

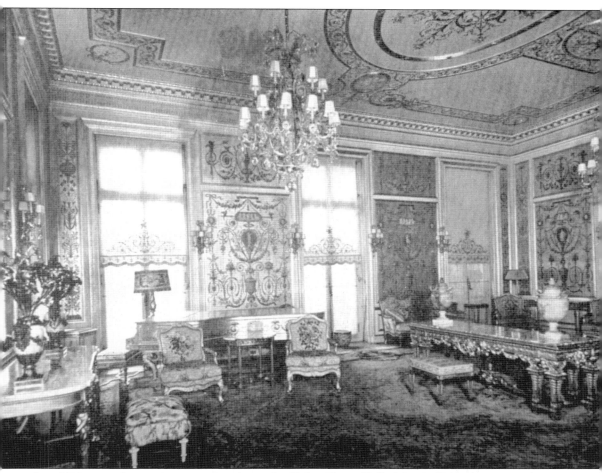

In addition to the music mezzanine located off the Great Hall, Maysie Parson oversaw the decoration of a separate music room.

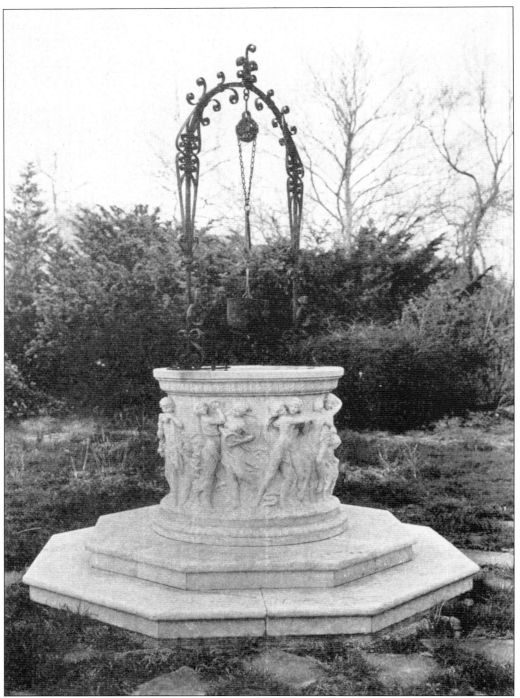

The Renaissance sculptured marble and wrought iron wishing well looks similar to the wishing well movie mogul Walter Reade Sr. placed in the lobby of his Moorish-style Mayfair Theatre in Asbury Park. Reade's son would later serve on the sponsoring committee of the Monmouth College Committee for Shadow Lawn.

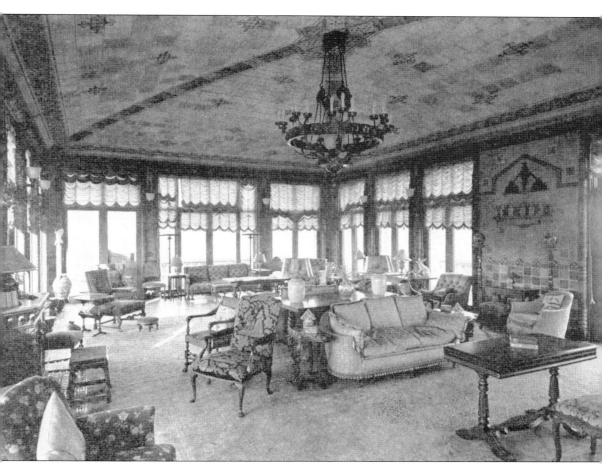

Maysie Parson's last-minute desire for a solarium on the rooftop of her country home interrupted the neoclassical architectural line of Shadow Lawn, contributed to the escalating costs of building and decorating the ode to Versailles, and became part of the property's cultural legacy and the end of the Gilded Age.

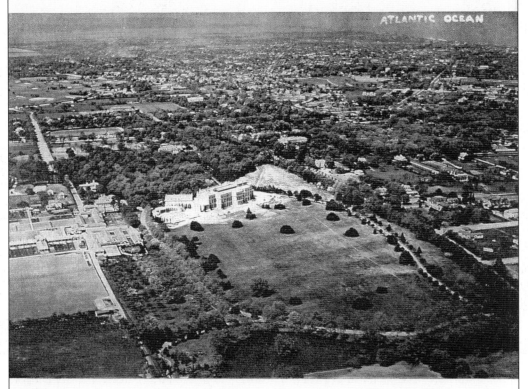

AERIAL VIEW

of

MONMOUTH MILITARY INSTITUTE

WEST LONG BRANCH, N. J.

ATLANTIC OCEAN

In the foreground of this aerial is the 108-acre estate, Shadow Lawn, admired by so many dignitaries during its occupancy by former President Woodrow Wilson, now the Monmouth Military Institute, West Long Branch, N. J. (Photo by Airview)

The *Asbury Park Press* reported on July 11, 1941, that the borough had leased Shadow Lawn to a syndicate operated by a Teaneck developer for conversion to a military school. This was the second time the site had been rented for use as a military academy in less than a year. The previous venture had failed; the five students who were enrolled were sent home. The institute's brochure listed everything from fees to staff, but it never opened.

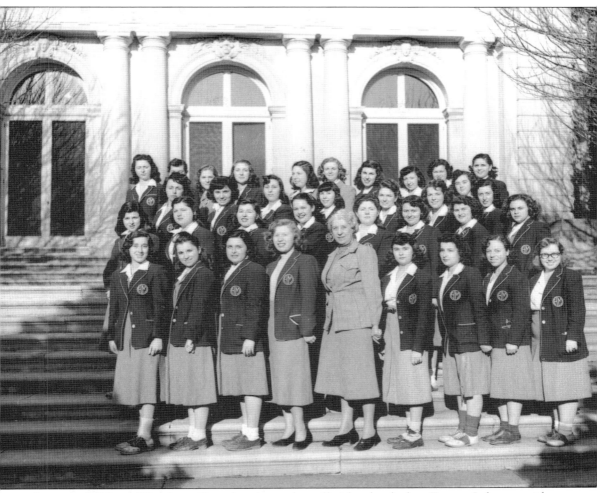

Instead of all boys, West Long Branch welcomed an all-girls school when Eugene Lehman paid $100,000 for the Shadow Lawn property in February 1942. He also acquired the old Leopold Stern estate across Cedar Avenue. A popular myth has the actress Lauren Bacall (née Betty Joan Perske) attending Highland Manor after its relocation to West Long Branch. In fact, she attended the school when the campus was in Tarrytown, New York.

Eugene Heitler Lehman graduated from high school in Pueblo, Colorado, and then matriculated at Yale University, where he acquitted himself as an orator and won prizes in history and English. In 1902, he was named the first American to receive a Rhodes Scholarship to study in Oxford, England, but studied at the University of Berlin instead. He taught English at the Jewish Theological Seminary of America. In 1910, he became director of the Highland Nature Camp for Girls on Lake Sebago in Maine with the woman who would become his first wife, Madeleine. In 1915, he cofounded the Lehman-Leete School for Girls in New York. In 1920, the school was moved to Tarrytown and renamed the Highland Manor Boarding School for Girls, and later called the Highland Manor Junior College. As the Depression drew to a close, Lehman looked to the North Jersey shore to relocate one final time. The attraction was twofold: the Greater Long Branch area had a growing year-round German Jewish presence that was religiously and culturally vibrant, and there existed empty summer cottages of a bygone era that held the potential for conversion to classrooms.

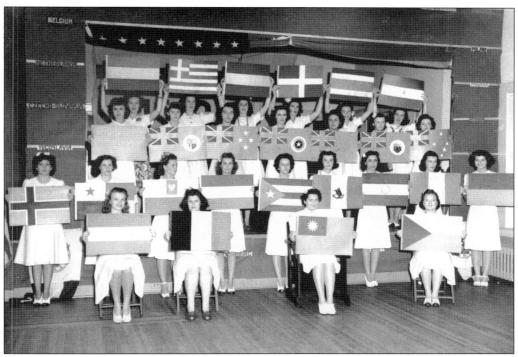

With Highland Manor's international student body, an emphasis on world cultures is evident in this presentation in the Shadow Lawn theater.

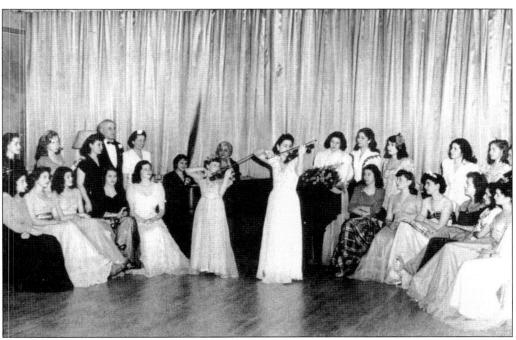

Students pose here during a violin recital for a Highland Manor brochure.

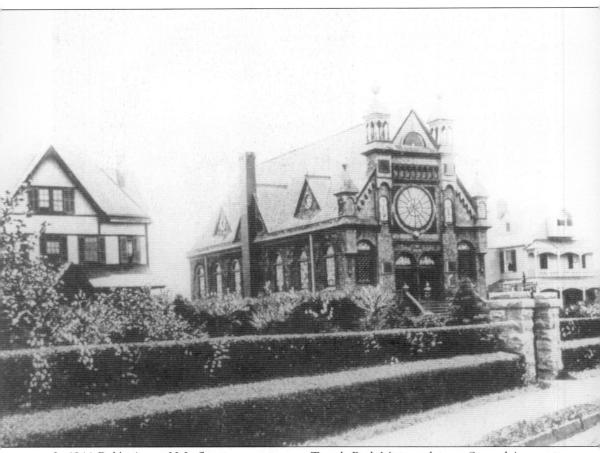

In 1944, Rabbi Aaron H. Lefkowitz came to serve Temple Beth Miriam, then on Second Avenue in Long Branch. At Highland Manor, he taught junior college Bible literature, according to *Manorisms*, the school's yearbook. Also from Second Avenue came Dr. Jerome Lasky to teach science. The synagogue was also the house of worship during the summer for Leonie Guggenheim.

Highland Manor enrolled day students in addition to those who boarded from New York and such Spanish-speaking countries as Cuba and Venezuela. Here is Margery Carroll, from the class of 1946, then of Little Silver, who went on to dance on Broadway. She is best known locally for her School of Ballet, which she has operated on Monmouth Road in Eatontown for nearly 50 years.

In the summer of 1952, Gordon Witt's Dancing School held classes in the lower-level theater. Here West Long Branch siblings Diane DeBruin Carlisle, then 10 years old, and her brother, Thomas, are dressed for their graduation dance.

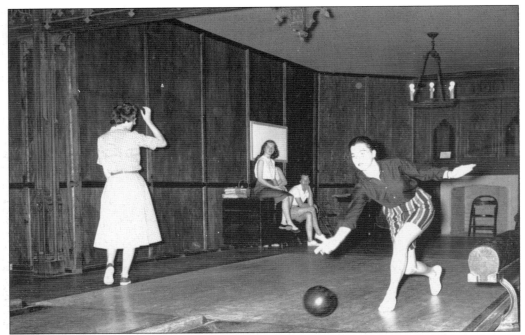

Hubert and Maysie Parson may never have hosted a bowling party at Shadow Lawn, but the Highland Manor girls got into the swing of the sport with gusto, for this photograph opportunity at least.

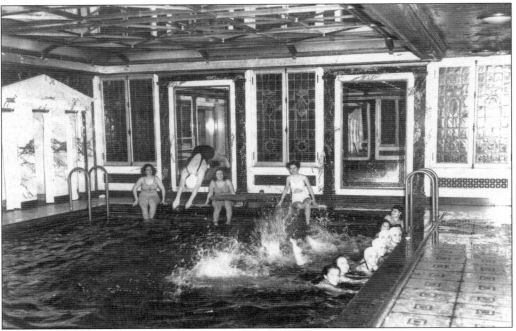

The mansion's indoor basement pool, in all its marbled splendor, was quite the ideal environment for young ladies of means and was a natural fit for Eugene Lehman's vigorous emphasis on athletics to improve the body as well as the mind.

Lehman and his first wife, Madeleine, operated the Highland Nature Camp on Lake Sebago in Maine. Later he would also include the name Highland Manor Summer School.

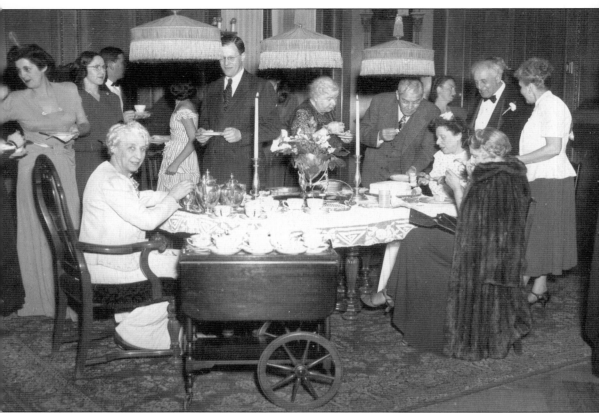

Among the Highland Manor traditions was senior tea. Elizabeth Lehman sits on the right, with a flower in her hair; her husband is wearing a white carnation on his lapel. Serving tea is Elizabeth's sister, Mrs. Samuel Chase, seated at left.

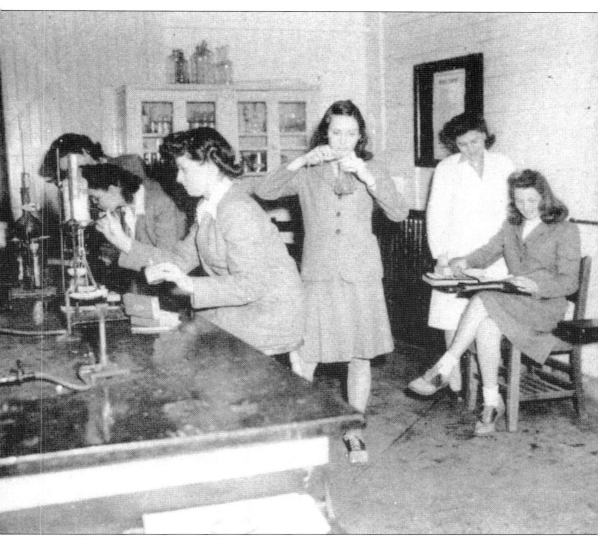

Hubert Parson's agricultural buildings were readapted for various educational purposes. Here is the chemistry laboratory.

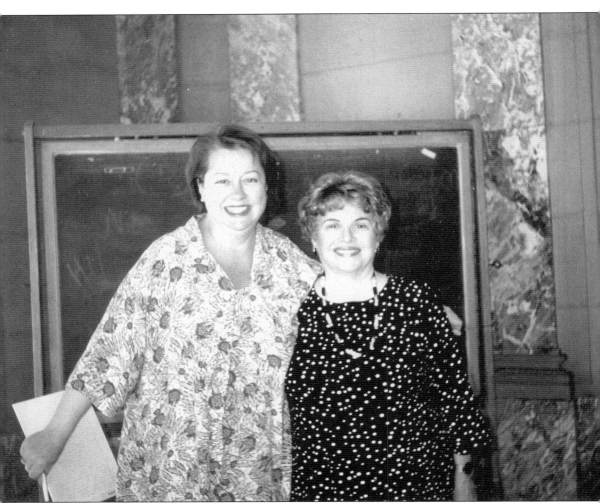

Here is the author (left) and Mimi Kates Lourenso during a Highland Manor reunion in the Empire loggia at Shadow Lawn in 2000.

"Dr. Lehman (as I remembered we called him) was very bright and admired by all. He was a kind and respected person. He was like a philosopher, and sermonized to all of us, every Sunday morning, downstairs in the auditorium: the need for cooperation among men. His main theme was stressing how it would be a better world and wars would be eliminated if there was only co-operation in man's dealing with mankind," wrote Mimi Kates Lourenso in 1995. In this photograph, a young Mimi Kates leads the graduation processional into the Great Hall. After 14 years on Cedar Avenue and with no successor, plus the burgeoning Monmouth Junior College overflowing its rented rooms in the Long Branch Senior High School, Eugene Lehman was about to find a new academic opportunity for his cottages-turned-classrooms. The last official class to graduate from Highland Manor was in 1959.

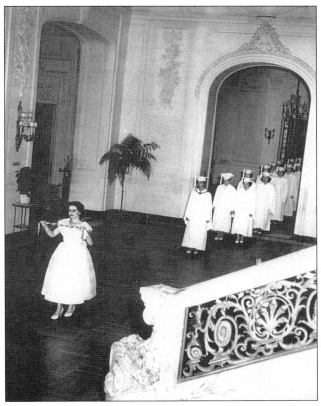

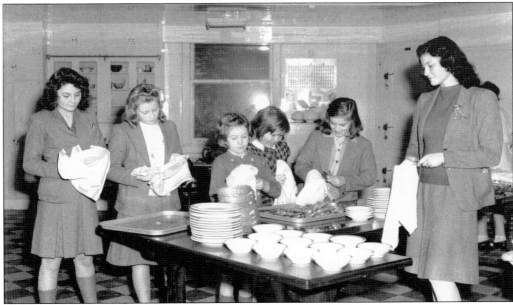

The servants, or west, wing also was the site of the mansion's kitchen facilities. The latter was used by Highland Manor as a cafeteria. Known as Bambi Hall, the upper floors were used as one of the girls dormitories.

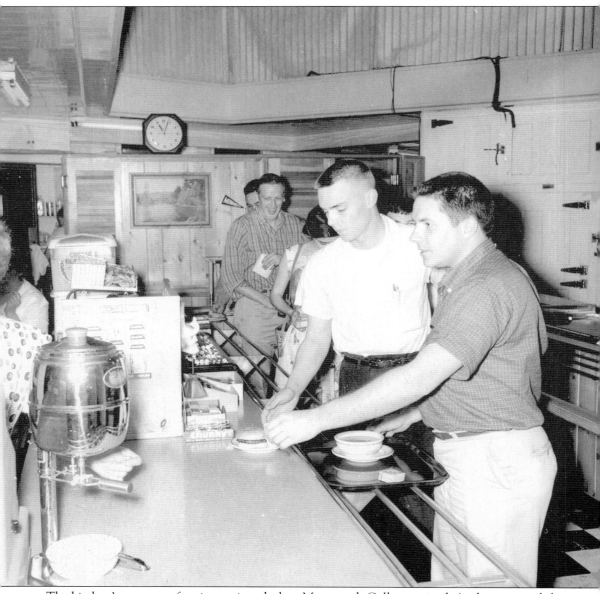

The kitchen's use as a cafeteria continued when Monmouth College arrived. At the extreme left is Louise Herberg, who operated the facility for the college.

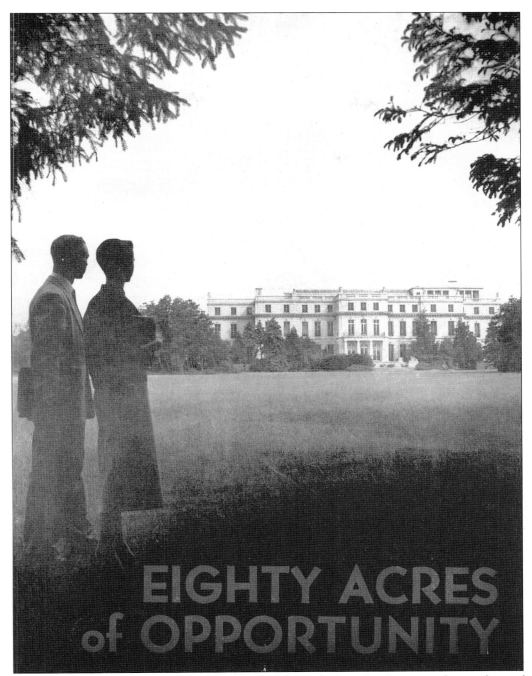

EIGHTY ACRES of OPPORTUNITY

Eighty Acres of Opportunity was probably the first full-length glossy brochure aimed at residents of Monmouth County to solicit their support, so the two-year junior college founded by Edward G. Schlaeffer in 1933 at Long Branch High School could be realized as a four-year institution. For young people, now and in generations to come, Monmouth College means opportunity.

MONMOUTH
COLLEGE

WEST LONG BRANCH NEW JERSEY

STUDENT HANDBOOK 1956-1957

Property of

MONMOUTH
JUNIOR COLLEGE
LONG BRANCH NEW JERSEY

Student
Handbook
1955—1956

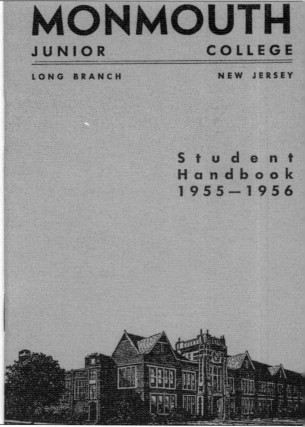

Architecture evolves from the Gothic architecture on Westwood Avenue to the French architecture of Cedar Avenue.

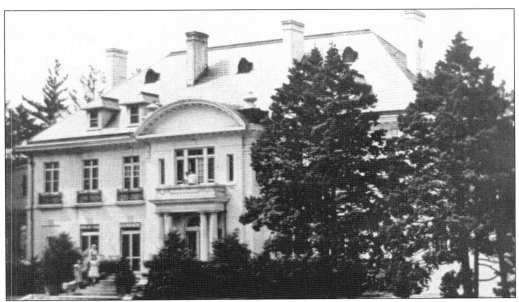

The Stern mansion, reborn as Beechwood Hall for Highland Manor, underwent a $25,000 transformation for Monmouth College in 1959. It housed a psychology laboratory, a music studio, a typist laboratory, and several offices. The 21 refurbished classrooms could house 800 students. In the 1960s, it was the student union; banners protesting America's involvement in Vietnam were hung from the second-floor balcony. The building was torn down in 1974, creating a public place for the college dormitories built throughout the 1970s.

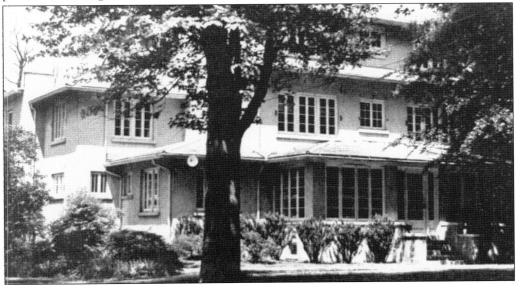

The Shadow Lawn caretaker's house is where the Parsons lived during the postfire reconstruction. It was known as Radcliff Hall, a dormitory, during the Highland Manor tenure. Then it was Monmouth College's original Business Administration School, eventually named for vice president of business affairs Clarence "Walt" Withey. It was torn down to make way for the university's School of Communications, named for *Asbury Park Press* executives Jules L. Plangere Jr. and Robert E. McAllen.

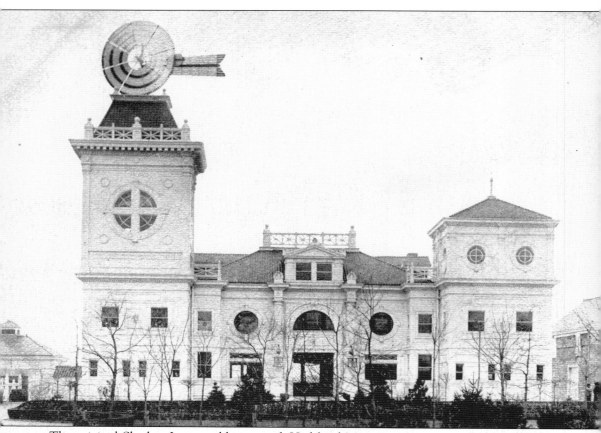

The original Shadow Lawn stables–turned–Highland Manor gymnasium is the only building still standing that was designed by John McCall's architect Henry Edward Creiger. Minus the windmill, the building today is the home of Monmouth University's art department.

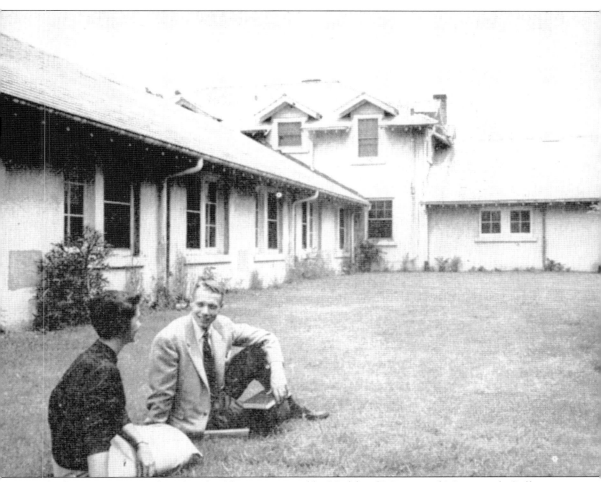

Shadow Lawn's agricultural outbuildings were used by Highland Manor and Monmouth College as biology classrooms. The grass has long since been paved over to create an interior courtyard that is part of the university's art department.

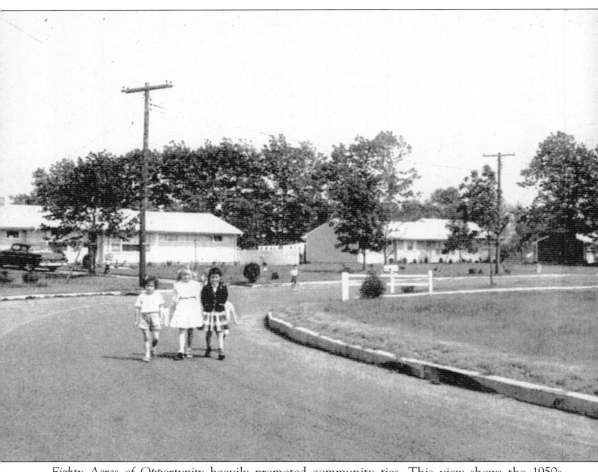

Eighty Acres of Opportunity heavily promoted community ties. This view shows the 1950s suburban neighborhood developed off Monmouth Road in the borough, south of the Parker Road intersection.

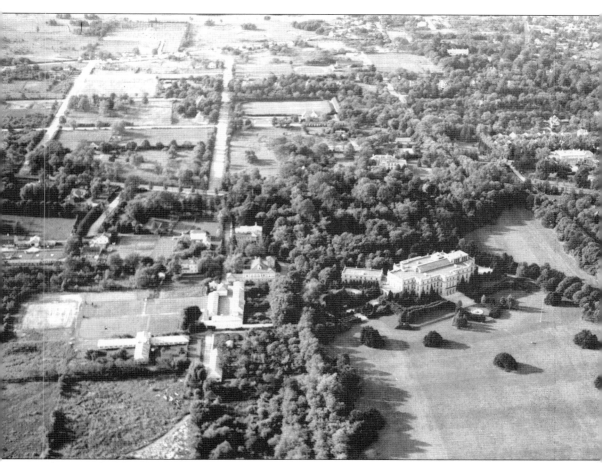

Photographed by the late Daniel Dorn Sr., this aerial view was the most frequently used for promotional purposes for the Shadow Lawn property. It captures the changing personality of West Long Branch in the late 1950s. West of Shadow Lawn one can see Marlu Farm. North of Cedar Avenue Kilkare Farm is visible, with its track for training racehorses, and so are Kitty Messner's "Peyton Place" estate, a few of the cottages actually built for Norwood Park, and several of the abandoned golf links from the old Norwood Country Club. Along the fringes of these large farms rented by the club, one can see residential subdivisions were occurring at the time. At the right, midway, are the rooftops of the Guggenheim mansion and the houses on Norwood Court.

From left to right, Long Branch city councilman, clothier, and college trustee Harry Vogel, U.S. senator Clifford Case, of Keyport, and board president William Smith are shown in July 1956.

CLASS OF SERVICE	WESTERN UNION	SYMBOLS
This is a fast message unless its deferred character is indicated by the proper symbol.	TELEGRAM W. P. MARSHALL, PRESIDENT	DL = Day Letter NL = Night Letter 1201 LT = International Letter Telegram

The filing time shown in the date line on domestic telegrams is STANDARD TIME at point of origin. Time of receipt is STANDARD TIME at point of destination

PA05 P ASA002(

P WA533) GOVT NL PD=THE WHITE HOUSE WASHINGTON DC 2=

=EDWARD G SCHLAEFER,PRESIDENT=

MONMOUTH COLLEGE WESTLONGBRANCH NJER

=IT IS A PLEASURE TO SEND GREETINGS TO THE STUDENTS,
FACULTY AND FRIENDS OF MONMOUTH COLLEGE JOINED IN THE
OBSERVANCE OF ITS 25TH ANNIVERSARY YEAR. IN A BRIEF
QUARTER CENTURY, MONMOUTH COLLEGE HAS BUILT A FINE
TRADITION OF LEARNING AND SERVICE. THIS HAS REQUIRED
MUCH HARD WORK, GOOD JUDGEMENT, AND A CLEAR VISION OF
THE ROLE OF SUCH AN INSTITUTION IN THE EDUCATIONAL LIFE
OF OUR PEOPLE. CONGRATULATIONS AND BEST WISHES=

DWIGHT D EISENHOWER=

This is a copy of a telegram from Pres. Dwight D. Eisenhower from the archives of the late Quentin Keith, who early on in the college's establishment was its development officer. He later joined the English department and retired in 1982 as a professor.

You are Invited to attend the
College Queen's Ball
at beautiful
Monmouth College

Norwood & Cedar Aves. West Long Branch

SATURDAY, JUNE 22

Dance to the Music of
nationally famous
TOMMY TUCKER
and his orchestra
9 P.M. to 1 A.M.

★ Presentation of
 Nationwide College
 Queens - 10 P.M.

★ Refreshments

★ Entertainment

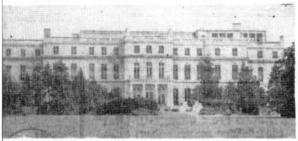

Proceeds From This Dance for the Benefit Monmouth College Fund

Monmouth College Queen
ELLEN LEHTONEN
EATONTOWN, N. J.

DONATIONS
College and High School Students
$5.00 per couple
All Others . . . 10.00 Per Couple

TICKETS - MAIL OR PHONE ORDER
Mrs. John J. Bell - 77 Park Lane
Fair Haven SHadyside 1-3195
—— or ——
Monmouth College - Miss Rubin
West Long Branch CApital 2-6600

The palatial surroundings naturally lent themselves to a ball, and still do today. Before he was hired to teach music, Tommy Tucker and his orchestra played for a 1957 college fund-raiser. It was while performing at the Berkeley-Carteret Hotel in Asbury Park that the North Dakotan met his wife and decided to settle down on the Jersey Shore in 1941. He later opened a store there that sold a combination of instruments and appliances on Main Street.

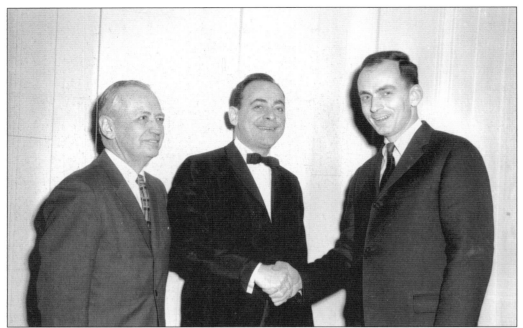

Big band leader Tommy Tucker was a music professor for 18 years at Monmouth College before retiring. This photograph was taken at a college event held in March 1961. The man at the right is Robert Hogg, director of student services for the college. The musician in the middle remains a mystery.

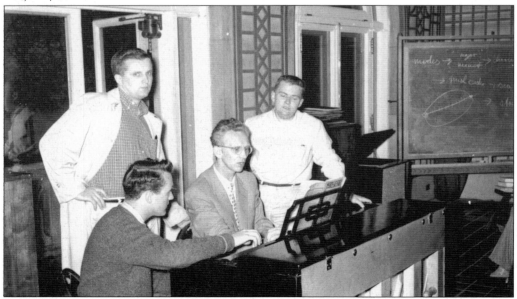

Austrian-born Felix Molzer was the first to tour the famed Vienna Boys Choir after World War II. After immigrating to the United States, he arrived at Monmouth College where he taught from 1955 to 1960 and again from 1992 to 1996. With his wife, Jeanette Ballentine Molzer, he started the Monmouth Conservatory of Music in Little Silver in 1962. He reestablished the Monmouth University Chorus and then retired in 1997. He is seen here in May 1959.

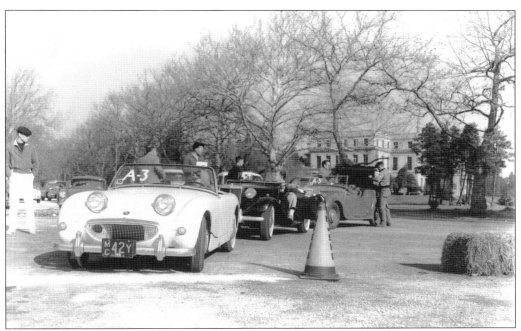

The Monmouth College Auto Sports Association was founded in 1958. Trials held on campus tested driving skills and timed performance at various speeds through a designated course.

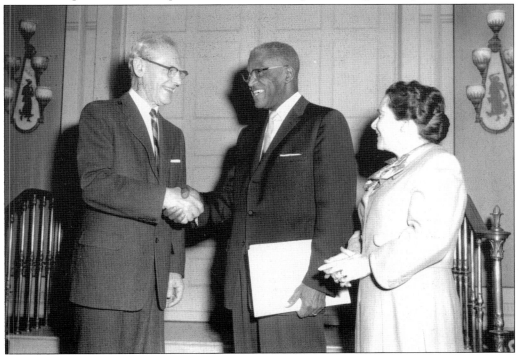

College president Edward Schlaeffer (left) is seen in this February 1961 image with Dr. James Parker Sr. of Red Bank, an original trustee of the college and a highly regarded local civic figure. Also in attendance is Janet Hobbie, the school's first library director.

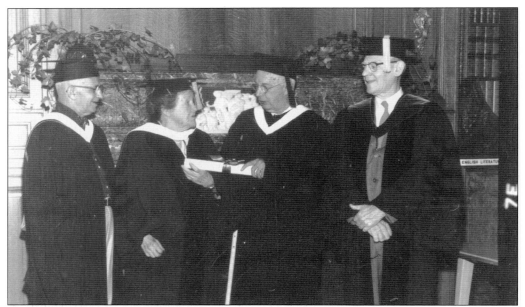

With college president Edward Schlaeffer looking on, Katherine Elkus White (whose father, Abram I. Elkus, had been Woodrow Wilson's ambassador to Turkey) receives an honorary degree from William Smith, president of the board of trustees. This photograph was taken at the first college graduation in 1959; White was a trustee and had not yet been named U.S. ambassador to Denmark. At left is Thomas Harper, the trustees' vice president.

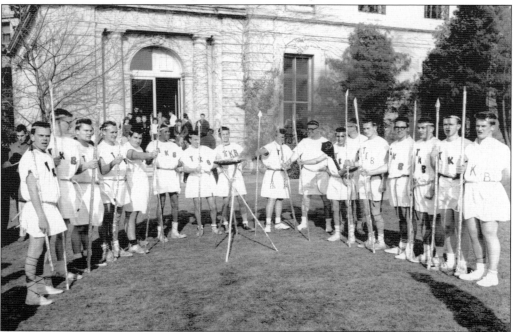

Tau Kappa Beta (TKB) was the first fraternity at Monmouth. The men were known for their postfinals and holiday parties, plus volunteering at the local blood bank and visiting patients at Monmouth Memorial Hospital. Insiders say TKB also stood for "tap-a keg-of beer."

Lucile and Maurice Pollak were among the earliest supporters of Monmouth College, with Maurice serving on the executive committee of the much larger Monmouth College Committee for Shadow Lawn. The Pollak name graces a much-used auditorium that anchors the row of classrooms headed by the Thomas Edison Science Building.

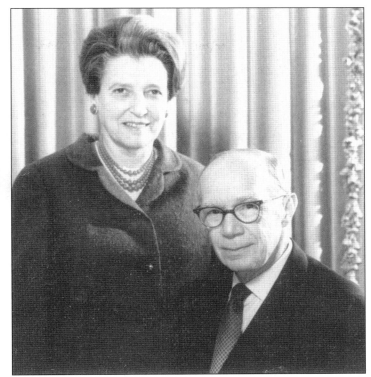

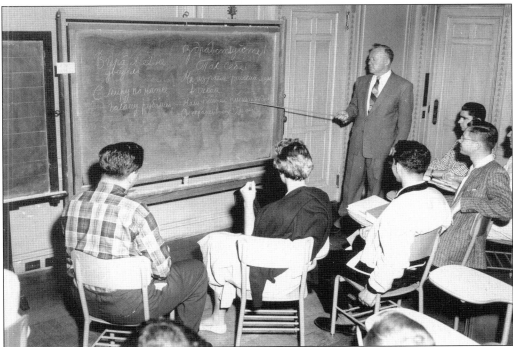

Here is Dr. Robert E. Pike, teaching French in one of the original Parson rooms in April 1957. The irony of his life at this juncture included his marriage to a native-born Parisian.

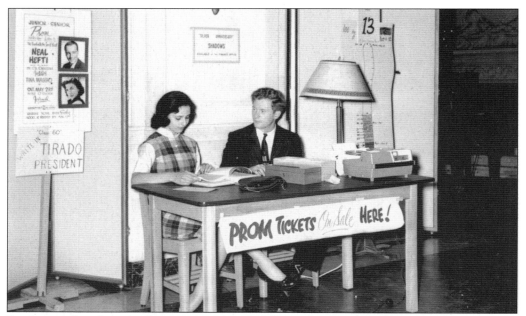

Students sell tickets to the junior prom of 1959 in the Great Hall in this Dorn's Classic Images photograph.

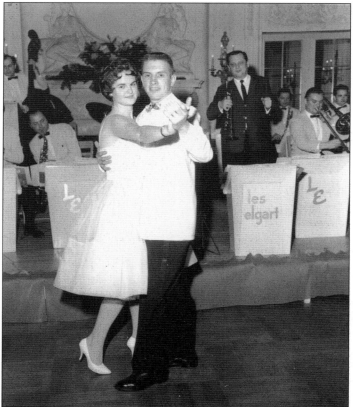

The class booked society bandleader Les Elgart. This may have been among the last of his touring gigs. The trumpeter retired later that year, although his brother Larry, the saxophonist, managed to coax him to play again in 1963.

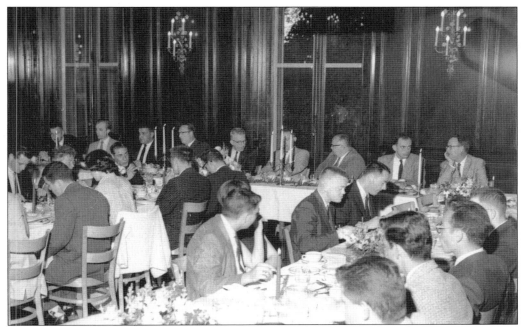

This image shows the 1959 sports banquet in the Versailles Room. At the head table, from left to right, are Marty Metzger, baseball team captain; unidentified; coach William T. Boylan; Dr. Vernon Heffernan, math professor; Clarence "Walt" Withey, business manager for Monmouth College; unidentified; Godfrey "Buzz" Buzzelli, baseball coach; Robert Hogg, student services, and unidentified. At the left table is basketball guard Bruce Fishbein, facing the camera and pointing with his finger. At the right table, Paul Caccio sits in profile with a buzz cut.

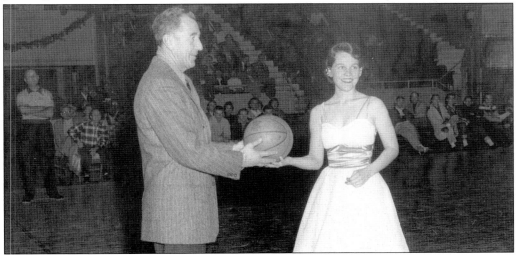

Freeholder Joseph Irwin and freshman queen Lee Gilbert are at the Hawks' first basketball game held in December 1957 at Convention Hall in Asbury Park. All home games were played here until the college built a gymnasium that honored the memory of the legendary basketball coach William T. Boylan. This photograph was taken by Alice H. Elmer of Neptune, a rarity as A. H. Elmer was the only woman professional photographer on the Jersey Shore in the 1950s. Most of her work centered on Asbury Park.

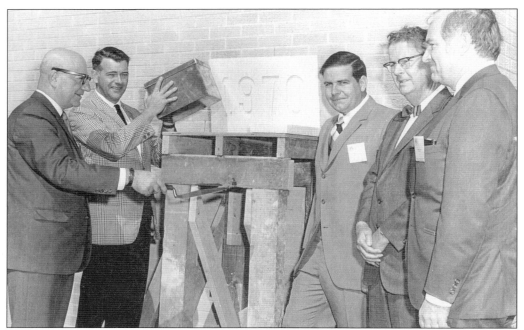

West Long Branch mayor Henry Shaheen (far left) and Asbury Park builder Henry Vaccaro (center) are at the ceremony to lay the official cornerstone of the Thomas Edison Science Building. To the right of Vaccaro is C. Norton Coe, then dean.

When Monmouth College began to build dormitories, the school stepped away from its original role as a local institution, and having enough beds is an ongoing challenge. This Dorn's Classic Images photograph, from the 1960s, was shot in the Harbor Island Spa at the eastern end of Cedar Avenue. Note that the students were put up in the rooms overlooking Ocean Avenue and not the Atlantic. The spire of St. Michael's Roman Catholic Church can be seen through the windowpane in the upper left corner.

Five

A QUICK LOOK BACK

As this volume is prepared in the fall of 2006 for publication, the historical character of West Long Branch continues to change. Once a mainstay of landscaping homes in the post–World War II era, Frank's Nursery on Monmouth Road is slated for conversion from commercial to residential use. The business had originally been started by brothers Artie and Ernie Turner on a portion of the old Dennis farm. Route 36, which separates the borough from Oceanport, continues to evolve as West Long Branch's main industrial/commercial thoroughfare, a trend also launched in the postwar years when the State of New Jersey created the highway to link the Garden State Parkway to the seashore, replacing Cedar Avenue as a main shore road. Throughout the borough, once well-preserved buildings are slipping from view, none more dramatically than the tollhouse operated by Egbert Hopper on the northeast corner of Monmouth Road and Palmer Avenue that had been lovingly restored by the late John Harvey and his wife in those years following the American bicentennial when historic preservation blossomed through the nation.

Environmentalists and longtime borough residents Mary Hance and Robert Owen in 2000 donated eight acres of their early-19th-century farm for passive recreation under the auspices of the Monmouth Conservation Foundation. Located on Wall Street, west of St. Jerome Roman Catholic Church, the farm, from which vegetables, milk, and eggs were sold, had been owned by Mary's grandparents, then her uncle, Dr. Owen Woolley, a dentist and one-time mayor, before Mary inherited the farm in 1969.

Electronic Associates Inc. (EAI) founder and Monmouth College trustee Lloyd Christiansen is seen here with his beloved wife, Shotsie (left). Next to them are Fred Martinson, EAI vice president of manufacturing, and his wife, Frances Townsend Martinson, longtime borough clerk.

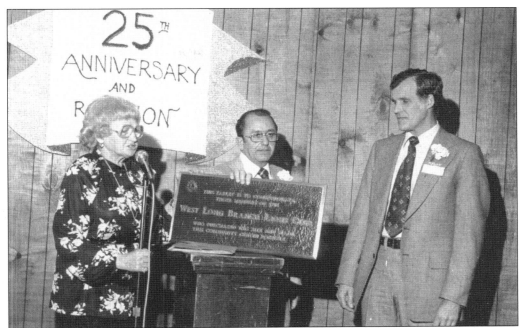

The Lion's Club has been the borough's longest-running civic group. Councilman Dick Cooper (right) is accompanied by the late mayor Clint Sorrentino and the community center's first director, Jo Wilderspin. They are at a ceremony honoring the Lions for their role in giving the borough what has turned out to be a much-loved institution in town.

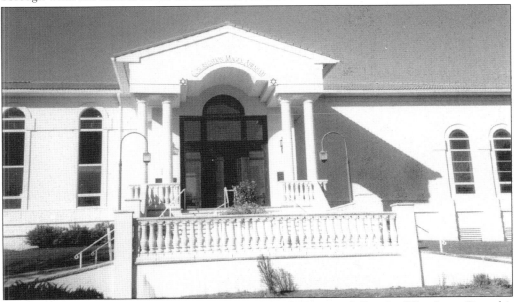

Congregation Magen Abraham on Cubero Court and Monmouth Road is West Long Branch's newest house of worship. The Orthodox synagogue is located just south of the Independent Methodist Cemetery, the borough's oldest graveyard. John Slocum was the first to be buried there in 1791. As a congregation, Magen Abraham follows the inspiration of 16th-century Spanish rabbi Joseph Caro.

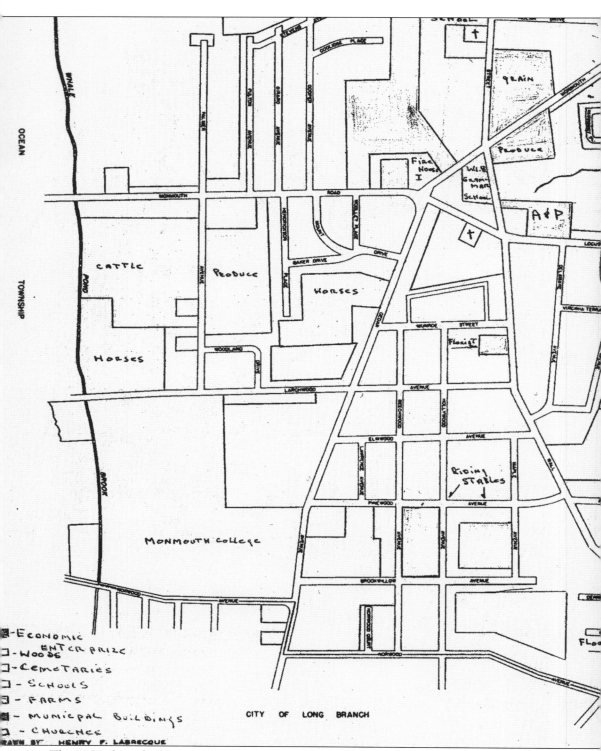

The 1950s brought change to West Long Branch: still enough open space to be considered

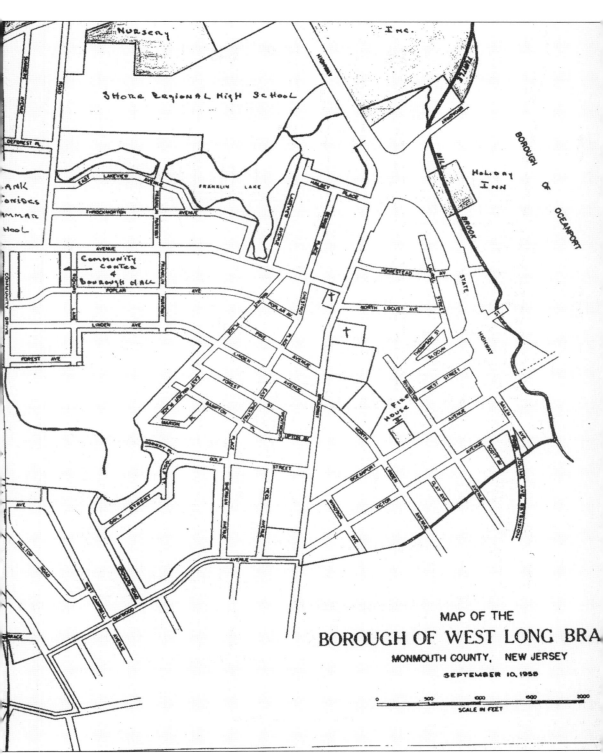

country, and nearly everyone in town knew one another or worked for people who did.

ACROSS AMERICA, PEOPLE ARE DISCOVERING SOMETHING WONDERFUL. *THEIR HERITAGE.*

Arcadia Publishing is the leading local history publisher in the United States. With more than 3,000 titles in print and hundreds of new titles released every year, Arcadia has extensive specialized experience chronicling the history of communities and celebrating America's hidden stories, bringing to life the people, places, and events from the past. To discover the history of other communities across the nation, please visit:

www.arcadiapublishing.com

Customized search tools allow you to find regional history books about the town where you grew up, the cities where your friends and family live, the town where your parents met, or even that retirement spot you've been dreaming about.